BEYOND
THE KILLING FIELDS

BEYOND
THE KILLING FIELDS

PHOTOGRAPHS BY
KARI RENÉ HALL

TEXT BY
JOSH GETLIN
KARI RENÉ HALL

EDITED BY
MARSHALL LUMSDEN

AN APERTURE BOOK

In association with California State University, Long Beach and Asia 2000

Published by Asia 2000 Ltd.
2nd Floor, Winning Centre
46-48 Wyndham Street
Central, Hong Kong

Library of Congress Cataloging-in-Publication Data

Hall, Kari René
Beyond the Killing Fields.

Photographs by Kari René Hall.
Text by Josh Getlin and Kari René Hall.

Library of Congress Catalog Number: 92-070075

Hardcover ISBN: 0-89381-504-7
Paperback ISBN: 0-89381-505-5

Produced in conjunction with California State University, Long Beach and Aperture, New York.

Aperture Foundation, Inc. publishes a periodical, books, and portfolios of fine photography to communicate with serious photographers and creative people everywhere. A complete catalog is available upon request from Aperture, 20 East 23rd Street, New York, New York 10010.

The photographer gratefully acknowledges support from the Eastman Kodak Co. in producing a slide show based on *Beyond the Killing Fields*.

Printed and bound by Eastern Printing, Bangkok, Thailand
Duotones by Frye and Smith, Costa Mesa, California

10 9 8 7 6 5 4 3 2 1
First Edition

Pages 2-3: Site 2 camp, with its thousands of bamboo huts inside a barbed-wire compound, houses nearly 200,000 residents. Situated on the Thai-Cambodian border, Site 2 is the largest Cambodian community in the world outside of Phnom Penh.

Page 4: A boy tosses a stone into a crater left by an artillery shell attack that killed nine people, injured eleven and destroyed several huts.

CONTENTS

Youngsters crowd into a hot, dusty field to watch handicapped soldiers compete in a one-legged race. Men missing one or both legs are a common sight in Cambodian refugee camps. Shelling, land mines and fighting are just part of every-day life. Most of these children were born in border camps and know the outside world only through the barbed wire.

THE DALAI LAMA

I t is moving to write this foreword to a book about the people of Cambodia who, like Tibetans, suffered one of the most brutal genocides under a repressive Communist regime. We Tibetans understand the human tragedy that Cambodia endures. Tragedies like this re-confirm my belief that the suffering of this world can only end when each one of us generates a sense of universal responsibility to our fellow beings.

Kari René Hall has written and photographed a compelling account of the life of 200,000 refugees inside Site 2 on the Thai-Cambodian border. This photo documentary, *Beyond the Killing Fields*, arouses the core of our compassion. It urges us to think, feel, act and renew our commitment to protect all peoples from ever experiencing or even witnessing such tumultuous tragedy.

We should not forget the plight of those fellow human beings who have been displaced from their homeland. We should also remember those who were left behind and try to provide them humanitarian assistance and solace. It is my hope that this book will generate a greater awareness around the world. I also appeal that we make every effort to bring about a change in the situation so that there is an end to the suffering of the Cambodian people.

I offer my prayers for a better future to the Cambodian people. May Cambodia and its people once again experience peace and happiness which they missed for too long.

August 13, 1991

9

Site 2

More than a decade after the brutality of the Khmer Rouge "killing fields," the nightmare continues for some 350,000 displaced Cambodians, who are daily subjected to crime, violence, economic deprivation and the constant threat of artillery shelling. Within the barbed-wire perimeters of these dismal refugee centers, nearly 50 percent of the population is under 14 years of age – the result of one of the highest birthrates in the world. By far the largest of the eight camps on the Thai border, Site 2 has come to epitomize the tragedy of Cambodian refugees.

SITE 2
(K.P.N.L.F.)
198,582

KHAO-I-DANG
(U.N.H.C.R.)
14,734

PHANAT NIKHOM
(U.N.H.C.R.)
695

SITE 8
(Khmer Rouge)
41,681

SITE K
(Khmer Rouge)
10,866

SOK SANN
(K.P.N.L.F.)
9,485

O' TRAO
(Khmer Rouge)
17,526

SITE B
(Sihanouk)
63,157

CAMBODIA
(KAMPUCHEA)

Samrong

Sisophon

Angkor Wat
Siem Reap

Battambang

Stung Treng

Kompong Thom

Pursat

Kompong Cham

Phnom Penh

Takeo

Kampot

Source: United Nations Border Relief Operation, July 31, 1991

FOREWORD

The tragedy of refugees, displaced persons and war victims is a universal story, but it is particularly significant in the case of Cambodia.

I was a victim of the genocidal Khmer Rouge regime, forced to live under the Pol Pot dictatorship for four years until I was able to escape. During those years, I was an eyewitness to torture, murder and forced starvation. The Khmer Rouge killed one to two million of my people, and would have killed more if they had not been toppled from power in 1979.

My story, as shown in the film, *The Killing Fields*, is not mine alone. It is the story of war victims throughout the world. And while many people condemn the Cambodian holocaust, little is being done to prevent another tragedy taking place today, on the Thai-Cambodian border.

Since 1979, more than 300,000 Cambodians have fled their homeland, seeking refuge from the Khmer Rouge and a bloody civil war. Although they want a better life for themselves and their children, like any other refugees, they have been categorized as displaced persons, stripped of most rights, and forced to live in camps until the day comes when they can return home.

Mostly women and children, they are trapped "inside the fence," pawns in the political tug-of-war between West and East. Some have been on the border for 12 years, and virtually all have been traumatized by the Khmer Rouge in one way or another. The only things they see are dusty fields, barbed wire and miles of tiny huts. Many of the children have never even seen their homeland.

I am proud to be a citizen of the United States of America. I have a job, a home and a country. I applaud the American people because they have a tradition of helping suffering people. And so I plead with them to show compassion once again, for some 350,000 Cambodians living on the border. We must not forget them.

Beyond the Killing Fields is a powerful documentary about the people living in Site 2, the largest border camp. In pictures and words, it reveals the tragedy of Cambodia that has continued long after the Khmer Rouge. I urge you to read it, and share it with your neighbors. I am glad you care.

DITH PRAN
Cambodian Holocaust Survivor

PREFACE

There was no 911 in the Site 2 camp, no one to call for help.

"Go! Hurry!" The young man was pulling me out of the hut. To my protests, he answered, "Forget about him. Let them settle it. Don't worry."

Over the pounding of my heart, all I could hear were thuds and screams. I kept yelling, "I can't go! Tell him, I don't care about the camera! Somebody has to make him stop!"

The young man tried to reassure me. "Tomorrow we will find someone better for pictures," he insisted. "Don't worry. There is nothing you can do. He will get your camera back."

I ran to the nearest hospital and still couldn't find anyone willing to stop the axe attack. "It happens all the time," I was told. There are 10 to 12 axe attacks every day. There was nothing they could do to stop it. Finally, I convinced a doctor to return to the scene with me. Maybe she couldn't do anything to stop the attack, but I had to know if Chan Peov had just hacked that man to death for stealing my little auto-focus camera.

As we approached the hut, the crowd fell silent. The doctor asked in Khmer what had happened. Using wild swinging motions, they accented the story with "chop, chop, chop, chop."

To my great relief, out walked the injured man. He held up his bleeding hand and yelled that Peov was out chasing the real thief with an axe to get my camera back. The victim was furious. He had been knocked unconscious, and, worse yet, his honor had been tarnished. He vowed revenge.

Back at the hospital, the staff wanted to know why I was so far out in the Site 2 sections, away from the road, alone, and without a two-way radio. Journalists are to have a guide at all times, I was reminded. It was very dangerous out there.

As I was about to leave the hospital, Peov came looking for me. His head lowered, he apologized profusely through an interpreter that he had been unable to get my camera back.

"I don't care about the camera," I kept telling Peov. "Please don't hurt anyone else. Forget about the camera."

He was not convinced. "It was a terrible dishonor for my family that your camera was stolen from our home. I am so proud to have you photograph me, to represent all handicapped soldiers. Now this terrible thing happens." Peov paused and pleaded, looking up at me for the first time, "Will you come back tomorrow to take more pictures?"

Since I had kept the camp open 30 minutes late, I missed the last of the relief vans and had to get a ride out with the U.N. security officer closing the camp for the day. As we were leaving, I

apologized for the problem and for raising the security level. The security officer laughed. It took a lot more than a crazed man running around with an axe to put the camp on alert, he said. Today was only normal. Site 2 was closing with Situation "zero" – all is calm.

While the incident was an often-repeated drama at Site 2, it gave me a close look at the explosive tempers and lawlessness that few relief workers ever see. Statistics spoke of ever-increasing violence, suicide and child abuse. But on that day, I learned a great deal more about honor, family devotion and the value of life in a war zone.

I had gotten my first glimpse of the displaced Cambodians on the Thai border in 1986 when reporter Josh Getlin and I accompanied a Congressional delegation's tour through Site 2.

The whirlwind tour whizzed us from section to section in air-conditioned buses. Nicely dressed girls held up signs such as "Please Rescue Cambodia" and "We Have Manpower. We Need Arms and Education." A women's association; cute little orphans; old people; smiling Khmer mothers holding their plump babies, all stood in orderly lines. They sang, waved, clapped and smiled.

Beyond the administration offices, wood fires cast a smoky haze over the nearby huts. I could see women wearing ragged clothes surrounded by nude and partially clad children. They weren't smiling or waving. When I tried to walk down a dusty road to get closer, armed guards barred the way, forceably signaling that I was not to stray from the planned itinerary.

Back in my hotel room after an exhausting day, I flipped on the TV while cleaning the red dust out of my cameras. The movie in progress was *The Killing Fields*. The Dith Pran character (played by Haing S. Ngor) was walking through the rice paddies and slipping into muddy pits of skulls and bones. I had just seen the real-life survivors of that Khmer Rouge madness.

I already knew about the Cambodian genocide depicted in the film, and I had taken a special interest in photographing Southeast Asian refugees in my Southern California community. I had even heard Dith Pran speak at a university.

But I had not realized that more than a quarter-million Cambodians, mostly women and children, are still languishing in dismal border camps. Ineligible for resettlement in a third country, they are just waiting to go home.

I kept wondering: How are the Khmer holding up in these inhumane conditions after all these years? How does everyday life go on within a war zone? What happens to children growing up with

their homeland clearly visible just across the barbed wire and minefield? How do teenagers go to school and plan ahead when their future looks so bleak? Have Buddhism, dance, and ancient traditions survived?

Obsessed by the idea of documenting the effect of living in this barbed-wire asylum, I would have to go back. For the next two years, I researched, saved money and hoarded vacation time.

Finally, I was able to return to Site 2 early in 1988. Nothing was easy. Logistics, bureaucracy and military restrictions made for daily problems. Early every morning I had to hitchhike the 100 kilometers to Site 2, catching rides in relief vans, military trucks, on public buses, motorcycle taxis and even on top of a vegetable truck. Each day I had to shoot as if it were my last chance in camp. The nearby shelling could close the camp for days or weeks at a time. At the mercy of the Thai military, camp officials might decide to deny my camerapass, which had to be renewed each week. The Thai guard assigned as my "guide" would intimidate people I was photographing or could catch me pointing a camera at one of the forbidden subjects: a checkpoint, a guerrilla soldier or a Thai guard. An unfavorable report on my activities would surely end my access.

I met a witch doctor whose magic could not be photographed; a classical dancer who knew the great stages of the world and now teaches youngsters that exquisite but nearly lost art; a battered wife whose husband had just attempted suicide by choking himself; a teacher unveiling the camp's very first computer, powered by a small, noisy generator.

I was privileged to witness a childbirth, a wedding and a funeral and learned the steps of "ram vong" at a high-school dance; was treated by a traditional healer's coining and herbal elixirs. I was evacuated following the kidnapping of a relief worker, and felt the ground quake from artillery attacks on the nearby guerrilla bases.

But most memorable were the Khmer, who opened their homes and their lives. Not once was I turned away. I was deeply touched by the warmth of their hospitality and their openness in sharing stories of unimaginable terror and awful personal loss, while still permitting themselves dreams for a better future.

There was Chan Peov, the handicapped soldier hoping against the odds to someday be a rice farmer; a teenage girl studying hotel management to be a travel agent in a rejuvenated Cambodia; a novice monk determined to strengthen the future of Buddhism; and an 18-year-old orphan,

yearning for, more than anything, a wife and family someday.

I will never forget the night I got special permission to stay after dark, a feat that took weeks of persuasion. The hot sticky night was menacing as shells sporadically pounded the military positions in the distance.

While doing a time exposure, I felt a small hand touch my leg. It was 10-year-old Chan Nak. In a camp of some 200,000, she had an uncanny knack of finding me. Her parents, Peov and Noeun, watched quietly from the shadows of a nighttime market. She stood with her hand on my leg as I packed my equipment.

Something was up. I could read that in Peov's silence and his dark eyes.

When I asked what was wrong, he just shook his head. They insisted on walking with me and the security officer to the jeep. As I loaded my tripod onto the back seat, Peov hurriedly pushed his daughter to get in.

Suddenly, I realized what was happening. Peov wanted me to smuggle Nak out of camp. He explained, "She loves you very much and wants you to be her new mother." I knew that her real mother had been killed by an artillery shell. She wrapped both arms around my legs and held tight. I had to pry her off me literally and try to explain that I couldn't just take her home with me.

After that, Nak would run and hide whenever I came to visit her family, and it took days to win her trust again.

The Chan Peov family is among the population of nearly 350,000 enduring the long hot days of dull routine, and nights of fitful sleep amid the thunder of distant shelling. It has been more than a decade since most of them fled to the border encampments. Their stories did not come easily. Sometimes they began with tears, sometimes an uneasy laugh to mask their pain. Some told of great hope for the future, while others expressed fear and despair. Many ended with a plea: "Please do not forget that we are here." Nearly all expressed a common dream: to return home soon.

KARI RENÉ HALL
1991

LOOKING INTO DARKNESS

BY JOSH GETLIN

T his book draws its title from the Khmer Rouge genocide that took the lives of more than one million Cambodians from 1975-1979. By now, the story is well-known: In a paroxysm of hatred and brutality, a clique of fanatic guerrilla leaders wiped out nearly 20 percent of the population of their own country, slaughtering entire families and all but destroying a culture that was once the envy of the world.

Driven by an intense hatred of the West, the Khmer Rouge (Red Khmer) tried to turn Cambodian life back to the "year zero," and in the process entire cities were emptied of residents. Thousands of people thought to be disloyal were executed on the spot and those who survived, including hospital patients, were forced to march many miles to labor camps in the jungles of Cambodia.

Amid heavy propaganda, children were turned against their parents and forced to pledge allegiance to Pol Pot, the head of the Khmer Rouge forces. Intellectuals, doctors, attorneys, Buddhist monks, scientists and educators were tortured or murdered, decimating what was left of the Cambodian middle class. Starvation and disease killed thousands more.

The Khmer Rouge came to power after toppling the government of President Lon Nol, a Cambodian leader whose corruption-riddled regime had been propped up with heavy United States military assistance. Earlier, U.S. intelligence played a key role in helping Lon Nol overthrow the government of Prince Norodom Sihanouk in 1970. At first, American forces were deployed heavily in defense of Lon Nol's regime. But as U.S. involvement in the Vietnam War began winding down, the Cambodian government was left to fend for itself.

After a protracted campaign, Khmer Rouge soldiers routed Lon Nol's army on April 17, 1975, plunging the nation of less than seven million people into darkness. For most readers, the grim saga of the "killing fields" is unforgettable, an Asian Auschwitz that will take its place among the supreme crimes of this or any other century. Told in books, movies and television documentaries, it is a chilling reminder that the trauma of war and retribution in Southeast Asia continued long after the Vietnam War ended.

U nfortunately, though, that is all many seem to recall about Cambodia. In 1979, invading Vietnamese troops ousted the Khmer Rouge and began a lengthy occupation. The story of the little country with a bloody past began receding from the front pages. In today's world, news of massacres, famine and war spread with unbelievable speed, and the torment of one nation must compete with similar stories around the globe for 15 minutes of attention.

So it has been with Cambodia. Soon after the Khmer Rouge terror ended, a new nightmare began when thousands of Cambodians fled their homes and sought refuge along the Thailand border. Many of them camped in settlements just inside Cambodia, hoping for a quick return home. But then civil war erupted and all hopes of normalcy were dashed. On one side was the newly installed Cambodian government, supported by Vietnam and the Soviet Union. On the other side was a coalition of rebel armies opposed to the Phnom Penh government, backed by China, the United States and other Western nations.

The border camps that were supposed to disappear soon became semipermanent outposts for Cambodian resistance leaders. They were also natural military targets. In a fierce 1985 campaign, Vietnamese and allied Cambodian forces drove the inhabitants of these camps over the border into Thailand, where an estimated 350,000 remain to this day. The most visible victims of a war without end, they live in dusty, crowded camps, and are subject to artillery bombardment at any time.

Today, there are eight such camps along the border, including Site 2, the largest, with an estimated 200,000 residents. A sprawling bamboo slum in the middle of nowhere, it is the largest Cambodian community in the world outside of Phnom Penh. Like the other enclaves, Site 2 is a bitter, despairing place where even the strongest spirits can shatter.

Beyond the Killing Fields is the story of the people of Site 2 and their daily struggle to survive. It shows how life is lived under siege in a place that few Westerners ever visit.

Most at Site 2 would go home tomorrow, if they could. But so far, it has proven to be an impossible task. Thousands of refugees fled Cambodia when the Khmer Rouge were ousted, and they live in fear that the hated guerrilla leaders will return to power. An even greater number came to the border because they despised the Vietnamese and refused to fight in the Cambodian army. Still others left because their country was being destroyed by war, hoping to start life over in a new land.

The exodus began with a flood of people in 1979 and has continued through the present day. In the camps, Western relief workers distribute food, medicine and other essentials. But as the war drags on, the border Khmer have come to accept the bitter fact that they are truly homeless. Thai officials have made it clear that the Cambodians are not welcome to resettle in their country. Instead, they are kept under close surveillance in camps, one as little as 30 meters from the border. Men, women and children have been turned into a human buffer against Vietnamese or Cambodian troops, with little regard for their safety.

Just as important, Thai officials have labeled the Cambodians "displaced persons" instead of

refugees. It is a mark of second-class citizenship because, unlike refugees, displaced persons are not eligible for resettlement in foreign countries. Also, the displaced Khmer do not qualify for protection from the United Nations High Commissioner for Refugees, (U.N.H.C.R.) the most important international body overseeing the human rights of refugees. Instead, they are subject to the administrative whims of the Thai government.

Sensitive to criticism, the Thais point out that they have agreed to operate the border camps from the beginning, and at great financial cost. Indeed, Thailand has contributed economic resources and military forces to protect these encampments. So far, it has been the only country willing to house large numbers of the fleeing Khmer. Lately, Bangkok officials have urged a rapid solution to the war, so that Thailand and other nations can invest in the economic reconstruction of Cambodia.

But good intentions have not been enough. In 1982, amid growing concern for the safety of the border Khmer, a new international organization was formed to aid them. The United Nations Border Relief Operation (U.N.B.R.O.) was designed to distribute food, water, material for housing, and other assistance to the border camps. This aid was meant to be temporary, because the nations that financially support U.N.B.R.O. – including the United States, Japan and other Western European countries – all agreed that the Cambodians should go home as soon as possible.

After years of warfare and diplomatic bickering, a breakthrough of sorts was reached on October 23, 1991, when a Cambodian peace settlement was signed in Paris under the auspices of the United Nations. According to the plan, four of the factions in the country's bitter civil war would be disarmed and democratic elections were to be held within 18 months of the agreement. When conditions permitted, the displaced Cambodians in Thailand camps – including those at Site 2 – would be allowed to go home. Many observers, however, questioned whether the fragile peace would hold, and fighting broke out again hours after the Paris agreement was signed.

From the beginning, the Cambodian war has been fought by proxy. Each faction has a different superpower standing behind it, pulling the strings and orchestrating rival strategies. The Soviet Union, for example, has long backed the Vietnamese and the current Phnom Penh regime as a hedge against Chinese influence in Southeast Asia. It has contributed billions of dollars to the cause, mostly in military and economic aid.

Meanwhile, China, the United States and other Western nations have backed a coalition of three

rebel groups seeking to overthrow the Cambodian government. China has underwritten the Khmer Rouge, seeking to blunt Soviet and Vietnamese influence in the region. The United States and other Western nations have for similar reasons aided two non-Communist rebel groups, one headed by Prince Sihanouk and a second, the Khmer Peoples National Liberation Front, (K.P.N.L.F.) headed by former Cambodian Prime Minister Son Sann.

Increasingly, however, the rebel coalition has become an embarrassment to the West because of the involvement of the Khmer Rouge. The three resistance groups have mounted military actions in coordination with each other, and they have been known to exchange battlefield intelligence. Also, the coalition that includes Pol Pot has been recognized by the United Nations as Cambodia's official government. Incredibly, U.S. policy has had the effect of assisting and legitimizing the Khmer Rouge, if only indirectly.

Officially, that wasn't supposed to happen. U.S. policy has deplored the murderers who ruled Cambodia from 1975-1979. Congress has stipulated that America would provide covert aid, including military assistance, only to non-Communist rebels. Still, there was a troubling moral question: How could the nation contribute to a war effort dominated by Pol Pot and his henchmen?

The policy began unraveling in 1990, when it became clear that the Khmer Rouge forces were gaining the upper hand in their war against the Cambodian government. Key military targets were under attack by guerrilla armies, and the regime looked as though it might not be able to stem the tide. Rebel forces were blowing up bridges and railroad tracks in the interior, and also harassing larger cities like Battambang. Suddenly, the thought of the Khmer Rouge returning in triumph didn't seem so far-fetched after all.

Meanwhile, there were signs that the superpowers might be willing to resolve the conflict that they have helped to prolong. The Soviet Union served notice on Vietnam, for example, that it would not support an expensive military occupation indefinitely. Chinese leaders signaled that they would back a peace plan and halt aid to the Khmer Rouge, but only if Vietnam agreed to pull all of its troops out of Cambodia and allow an independent, freely chosen government to rule in Phnom Penh.

Late in 1989, Vietnam began withdrawing its army from Cambodia. At that point, American foreign policy began to shift. Under pressure from Congress, the Bush administration announced that it would no longer recognize the rebel forces as the "official" government of Cambodia in exile. Diplomatic feelers went out to Vietnam for the first time since the end of the war, hinting at an expanded political dialogue. Finally, Congress approved a law putting new limits on covert aid to

the Cambodian rebels, signaling a major break with past policy.

Against the backdrop of these superpower moves, the United Nations inched toward playing a key role in bringing the Cambodian war to an end. In 1990, the feuding Khmer factions agreed in principle on a complex formula by which a U.N. peacekeeping force would come to Cambodia and free elections would eventually be held. It seemed to be "the light at the end of the tunnel," as one high-ranking U.S. State Department official cautiously observed.

But this optimism has been slow to reach the refugees on the Thai-Cambodian border. They have heard these stories before, and few seem willing to believe their troubles will end any time soon. Many of them had great hopes for a 1989 Paris conference on Cambodia, for example, only to be disappointed when the meeting broke up acrimoniously, without achieving any results.

As of this writing, there are growing hopes that a U.N.-sponsored peace plan will finally bring an end to the fighting. But people continue to die in the killing fields and there is no timetable for the refugees' return. In the border camps, the Khmer live their lives one day at a time, viewing international events with skepticism and, in some cases, despair.

Currently, there are eight camps on the border. All are linked with one of the three rebel factions except for Khao I Dang and Phanat Nikhom, politically neutral enclaves under U.N. control. Site 2 is administered by the non-Communist K.P.N.L.F., which is split into rival factions. For many observers, the large camp nestled against the Dangrek mountains has come to epitomize the tragedy of Cambodian refugees. Ringed by barbed wire, it sits on a flat plain in a political no man's land, within earshot of the war. Visitors are strictly regulated by Thai militia, who control all movement in and out of the camp.

"For all they've been through, I think the Khmer in this camp are some of the toughest people I've ever met," said Marybeth McCarthy, a Western relief worker. "They have every reason in the world to give up. But even though they live in a hellish place, they never quite lose hope."

Although Site 2 is guarded by troops, the threat of an enemy attack is always near. Artillery shells frequently explode in the nearby mountains, and the camp is filled with small concrete bunkers for use in an emergency. Living on the edge of war, residents try to go about their daily lives with some kind of normalcy. But the routine is deceiving. Site 2 is a camp filled with anxiety. As an uneasy cease-fire takes hold, armed soldiers have turned into bandits, frequently terrorizing people in the camps.

Trapped in limbo, most Cambodians on the border have no sense of what it means to plan for the future, according to Andy Pendleton, U.N.B.R.O. field coordinator. Being displaced people, he says, "they believe that looking from one day to the next is like looking into the darkness. They don't live for the future, because the future just can't be seen. They become shadow people."

The only thing guaranteed to disturb the mind-dulling routine and lethargy at Site 2 is war. In some places, it is less than 30 meters from the Cambodian border. When enemy troops get near, rocket mortars can start dropping from the sky at any minute. Attacks usually come at night, increasing residents' fear.

"The Khmer are a tough people, and their ability to withstand the pressures of life in this camp is extraordinary," says Pendleton. "But everybody has his limits, and there are times when things get out of hand here. Security can be a nightmare."

The worst-case scenario for Site 2, says Pendleton, is a rocket attack that would cause a mass evacuation. Should that day ever come, plans exist to transport Site 2 residents to a new location, known as Site 3. The plan looks fine on paper. But some U.N.B.R.O. officials fear that politics could get in the way of a safe evacuation.

If shells started falling, K.P.N.L.F. leaders might balk at leaving the camp too quickly, fearing that they would be pushed farther away from the Cambodian border. It might come down to a political struggle between relief workers and camp administrators, with volunteers performing the lion's share of the evacuation, says one U.N.B.R.O. field hand. Amid the pressures of war, a lack of cooperation could be fatal.

"It would be the largest refugee camp on the move under shellfire in recent history," Pendleton says. "Site 3 would be mass havoc. You'd have seas of blue tents and people carrying everything they have on sticks, with children in their hands. If proper crisis-relief response weren't taken, there would be a lot of suffering there. It could turn into an awful tragedy."

Meanwhile, life at Site 2 goes on. In recent months, the security threat seemed to have diminished somewhat, but there is always the chance that a new governmental offensive could push rebel troops back to the western border, and right up against the camp's barbed wire.

In a recent letter sent from Site 2, Ly Noun, an 18-year-old orphan, voiced fears for the future and pleaded with a friend not to forget the border Khmer.

"We are so afraid of what will happen to us," he wrote. "But mostly we are afraid that the world will forget. You must never forget us. Please remember that we are still here."

A welcome to Site 2 is tempered by a show of force. The roads are cordoned off to pedestrian traffic, and every few feet, wary Thai soldiers guard the route, restlessly fingering their automatic weapons.

WELCOME TO SITE 2 – MOVE ALONG, PLEASE

To most of the world, evacuation Site 2 on the Thai-Cambodian border with its nearly 200,000 residents is a secret behind barbed wire. Journalists traipsing through the camp write occasional stories about the displaced Khmer (Cambodians), but few take a very hard look at the problems. A handful of film-makers have produced thoughtful documentaries, but Western television almost never visits the border. ■ Aside from the 340 relief workers in camp, the most common visitors are foreign dignitaries, for whom the Thai officials roll out the red carpet. Representatives of the United States, Western Europe and Asian countries sometimes tour Site 2, usually swinging by as an afterthought to a junket somewhere else. Accompanied by large caravans of press, interpreters, Khmer political leaders and Thai authorities, these visitors arrive in air-conditioned vans over the bumpy roads. They seldom spend much time at the camp. Rarely do they meet and talk to the people who actually live on the border. The visits of U.S. Congressional delegations to the camp are typical of Site 2's encounters with the power brokers of the outside world. ■ One such visit was made by Congressmen Gerald Solomon of New York and Christopher Smith of New Jersey. Site 2 put on its best face, while the U.S. delegation met with camp officials, who assured the congressmen that the anti-Communist forces were making progress. Later, the Congressional Record only carried a brief description of the stopover. "U.N.B.R.O. (United Nations Border Relief Operation) informed the congressmen," it said, "that camp residents, the majority of whom are children, pass the day playing, cleaning, and attending to camp duties."

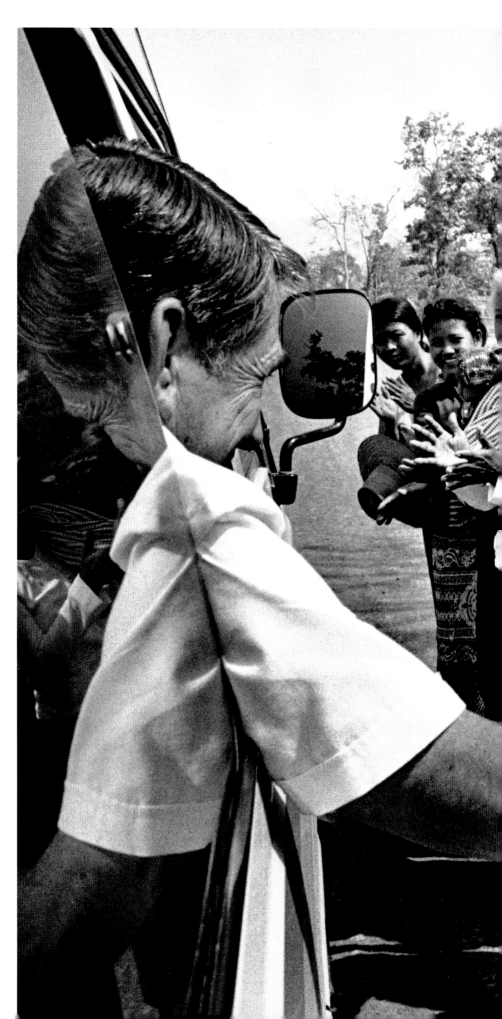

Congressmen Gerald Solomon of New York and Christopher Smith of New Jersey, both Republicans, stop in at Site 2 on a visit to Thailand. The camp leaders are ready for them.

Thousands of curious Khmer residents line the sides of the road. Wearing blue skirts and shorts prepared for such occasions, the children sing Cambodian songs as the congressmen, with their official entourage, pass by in their van.

Solomon and Smith make a short stop at an orphanage and get a fleeting glimpse of a school.

Mostly they are interested in talking to officials. The delegation makes a stop at each of the five administrative centers within the camp, where they enjoy a red-carpet welcome, complete with refreshments, and meet with section administrators. Representatives of the United Nations Border Relief Operation describe the situation in the camp for the congressmen.

General Dien Del reports on the success of the Khmer People's National Liberation Front (K.P.N.L.F.) and its strategy in the interior of Cambodia.

Khmer girls, dressed in white blouses for the occasion, hold signs (left) and chant slogans directed by camp administrators. The delegation meets at one of camp administration centers under a photograph of Former Cambodian Prime Minister Son Sann (bottom, left). Solomon waves farewell (below).

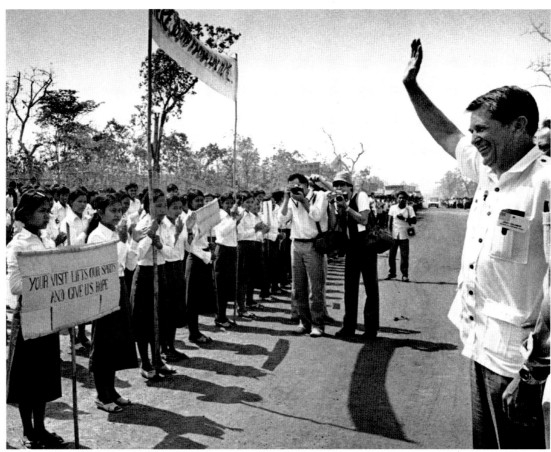

As Congressmen Solomon and Smith go from stop to stop in Site 2, their hosts hand them token gifts such as a woven tapestry. The visitors note that the residents of the camp look well-fed and that the facilities seem impressive.

Groups of orphans greet them, the smaller ones wearing crisp yellow and light-blue outfits complete with scarves and bonnets. Teenage boys are clad in blue T-shirts.

The Khmer Women's Association has a contingent on hand, and most groups hold up banners and signs, some carrying sayings such as "There is no place like home" – a message that is easily misunderstood in the setting of Site 2.

The congressmen pay special at-tention to cute little orphans, and one congressman picks up a small boy wearing a Boy Scout scarf and flashes the three-finger Scout salute as the boy smiles shyly.

The delegation leaves, passing lines of young women singing Ameri-can songs and holding signs praising aid from the United States.

As the vans pull out of camp, people along the route clap hands in unison. Hundreds of youngsters chant: "U.S.A., number one," and one child raises a sign reading "God Bless America."

"Now that's what I like to see," says one congressman to another.

In less than three hours, the visi-tors are gone to catch a plane that will take them back to Bangkok.

Murderer Soeurth Tha seems lost in another world as he shakes his manacled hands, complaining that a devil came into his head. Neighbors reported that he had been studying magic, trying to escape the unhappiness of living at Site 2.

BROKEN SPIRITS
SLIP OVER THE EDGE

As the visiting U.S. congressmen depart Site 2, the welcoming signs disappear. The tableau of hope and civility dissolves like a scrim on a stage. Adults and children return to their crowded huts, and the camp reverts to a raucous, filthy slum. ■ Under a searing sun, people argue bitterly over firewood, rice rations, water and clothing. Bamboo walls are thin, and no private family quarrel, discussion or moment of tenderness goes unnoticed. ■ Day fades into steamy evening, and thousands of small fires light the camp. Stray dogs roam listlessly along virtually abandoned roads. At night, artillery fire and exploding rockets resound in the nearby hills. After dark, bandits armed with hand grenades break into the compound. Some men leave their families to gamble and drink or spend their time with prostitutes. ■ Virtually every person in camp has suffered from the years of brutal Pol Pot rule. Even though most of these resilient people hold up well, the social fabric that binds the gentle Khmer wears dangerously thin under these inhuman conditions. "Imagine if anyone in America had to live in a large city every night with no electricity, no real police force to protect you," says Father Pierre Ceyrac, a French priest who serves as a relief worker at Site 2. "Under those conditions some people would go mad." Violence is common. Disputes were once settled with fists, sticks and firewood. But now axes and hand grenades, selling for half of a dollar, have become weapons of choice. There is a murder almost daily. The weak have little or no protection and sometimes lose their grip, slipping over the edge into despair and insanity.

Soeurth Tha awaits trial, confined in a bamboo jail cell after exploding in a drunken rage and killing his wife and daughter with an axe.

S oeurth Tha, a 38-year-old murderer, sits manacled in a Site 2 jail cell. Two days earlier he killed his wife, Sang Sareth, and his six-year-old daughter, Srey Mao. He had threatened them as they went out for a Saturday evening walk against his wishes.

"She never stayed home," he says, his eyes downcast. "She was always going somewhere. I didn't want them to go out at night. And I said this to my wife. If she goes out anywhere at night, I will kill her."

Hungry for entertainment, she disobeyed him, strolling with her daughter down the dark streets to a movie parlor. There they could watch popular Indian romances and Japanese martial-arts films on videos powered by a portable generator. Admission was 10 Thai baht – about one-fourth the value of the weekly rice ration.

While they were gone, Tha drank whiskey and brooded. When his wife and daughter returned, he screamed and struck them in the head with an axe, killing both instantly. Then he continued to batter them until they were unrecognizable. When it was over, he stood quietly, saying nothing, as the neighbors called for help.

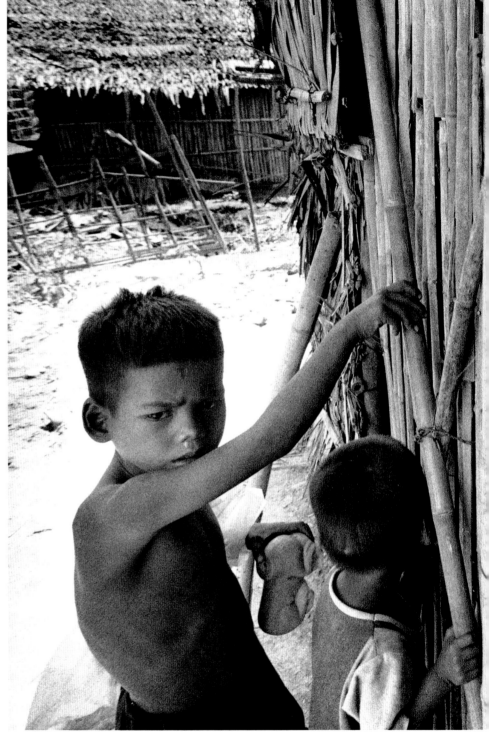

Tha's hut is looted until nothing remains but the empty whiskey bottles from the drunken rampage the night before. Alcohol abuse often ignites the volatile mixture of despair and frustration, as reflected in the alarming increase in violence and suicide.

Soeurth Tha's family was extremely poor. They kept to themselves and had few friends.

Now there is no one to care for the surviving child, a two-month-old baby boy, so he has been taken to the Khmer Civilian Protection Headquarters until authorities can decide what to do.

The morning after the murders, curious neighbors come to peer morbidly into the tiny, blood-spattered bamboo hut in a busy section of camp.

Even small children gather at the windows to view all that is left of Tha's meager possessions. They see inside only a small stone oven, some firewood,

an oil lamp, and a few tattered articles of clothing.

Before long, onlookers steal even these items. Also missing are Tha's remaining two bottles of whiskey, a cheap moonshine, popular in camp, laced with DDT for a spicy flavor.

Finally, only a few broken kitchen utensils, bloody rags and the empty bottles from the previous night's drinking remain.

In the end, Soeurth Tha's drunken rampage has resulted in the total destruction of his household. Even the hut will be torn down for its bamboo.

The bodies of Sang Sareth and Srey
Mao are placed side by side in the
same wooden coffin, which is paper-
ed in white and decorated with gold-
foil flowers.

According to Cambodian custom,
white handkerchiefs have been placed
over the disfigured faces, which are
battered and cut beyond recognition.

After a brief ceremony led by Bud-
dhist monks, the coffin is loaded onto
a wooden cart and a small funeral pro-
cession moves slowly through camp.

Taped music of high, eerie whistles
and drumbeats are broadcast by loud-
speaker along the way to announce the
deaths. Passersby remove their hats in
respect, and soldiers salute the funeral

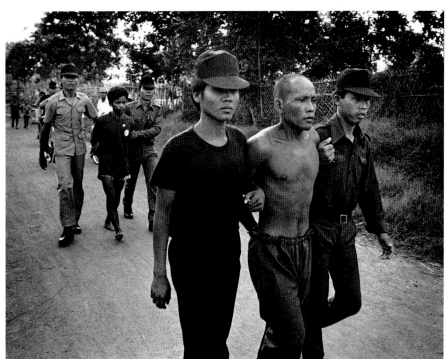

Buddhist monks conduct a small funeral for Tha's wife and daughter, as a neighbor peeks in at the bodies sharing a single coffin (left). Soeurth Tha (shirtless, below) and another accused murderer stand before a judge at a preliminary hearing. After the hearing, he is led back to his cell to await trial.

procession at the checkpoint.

At the edge of camp, the bodies are delivered to the outdoor crematorium. The coffin is returned for use at another funeral.

The next day Soeurth Tha and another accused murderer stand before a judge and a panel of witnesses to hear the charges against them.

Shirtless and shoeless, his head shaved and eyes distant, Tha can only mumble his answers in response to the judge's questions.

"A devil came into my head. It was magic," he says softly. "I want my family back, but I do not want to live here anymore. This camp, it is not a normal place to live."

Hem Chhel (left) is finally restrained by a friend after trying to choke himself. His battered and unforgiving wife, Khiev Eng, and daughter (right) refuse to see him anymore. The incident put an end to years of physical abuse, and forced Chhel out of Site 2 to a refugee hospital 100 kilometers away for treatment.

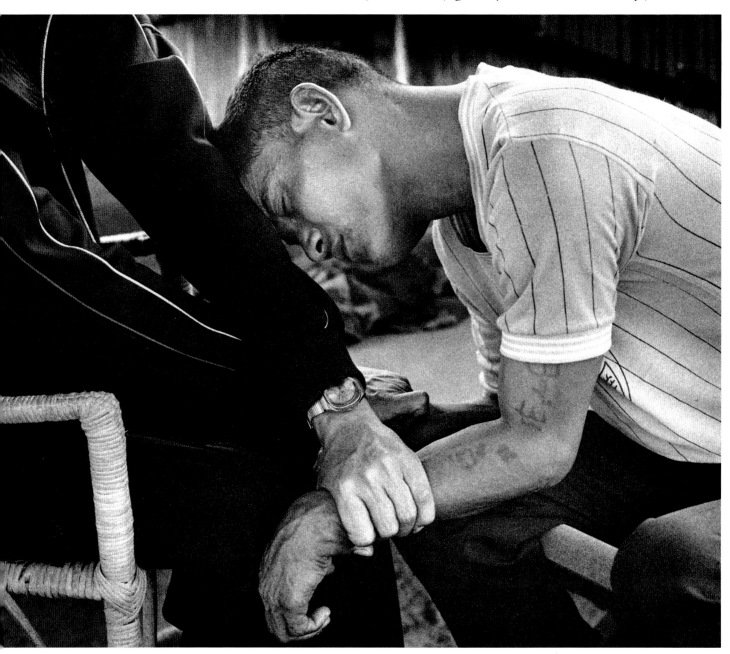

Hem Chhel wanted to die so much he tried to strangle himself. Relief workers found him with his hands around his neck, his face turning blue. When they tried to restrain him, Chhel fought back violently.

Even after sedation, he continued to choke himself and to bite his tongue, a gesture that expresses he no longer wants to live.

Chhel's wife, Khiev Eng, has left him and taken their three children with her. He wants his family back, but she refuses to return. For years, in his drunken rages, he has beaten her regularly, and once he choked her in front of their children. He has even threatened to kill her.

Now Khiev Eng has found a refuge in the Khmer People's Depression Relief Center, a special shelter set up for the mentally troubled.

36

Khiev Eng (below) and her children are gently counseled by Nuon Phaly at the Khmer People's Depression Relief Center. A week after an emotionally exhausted Khiev Eng moves with her children into a temporary hut, she finally begins to gain back her strength – and feeling of safety.

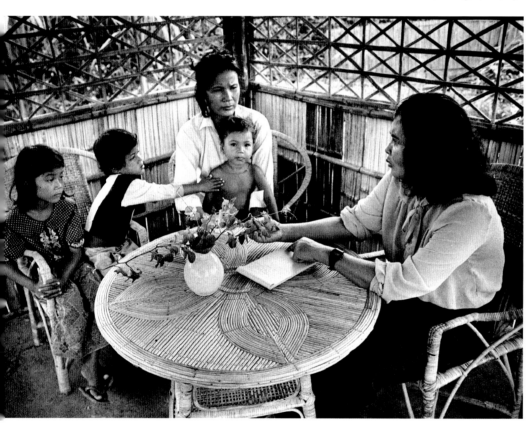

At the Khmer People's Depression Relief Center, Khiev Eng tells her problems to Nuon Phaly, the director of the counseling center.

"Sometimes I feel terribly depressed and want to kill myself," she says, "but because of my children I do not. I cannot trust my husband to take care of our children."

At the center, which was set up in 1983 by the Cambodians themselves in an attempt to blend Western counseling with Cambodian healing methods, Khiev Eng and her children move into temporary huts with several other women and their children who have also fled crises at home.

Problems range from traumatic Khmer Rouge memories and domestic abuse to aches and pains that have been brought on by mental stress.

Nuon Phaly, whose own family was devastated by Pol Pot, is spiritual healing counselor at the center and also works closely with staff at the Western-run hospitals in camp.

"Our people are grieving and this camp is no place for them to be," she says. "There is too much pain for them to face every day. Many people have broken hearts."

Khiev Eng never expected that her husband would become so violent. "I never thought of him this way when we first met," she says, "But we have been together, then apart, many times. And now he has threatened me with a knife."

Several times he has tried to see her at the center, but when he comes, she hides. Chhel has told friends that if he could persuade Eng to leave the center, he would kill her and sell the children to rich people.

The two were married in 1979 and came to the border the next year. Now, her marriage in ruins, Eng cares only about protecting her children.

She will be safe, Phaly assures her, and they will teach her embroidery to keep her busy, but beyond that, the future is up to her.

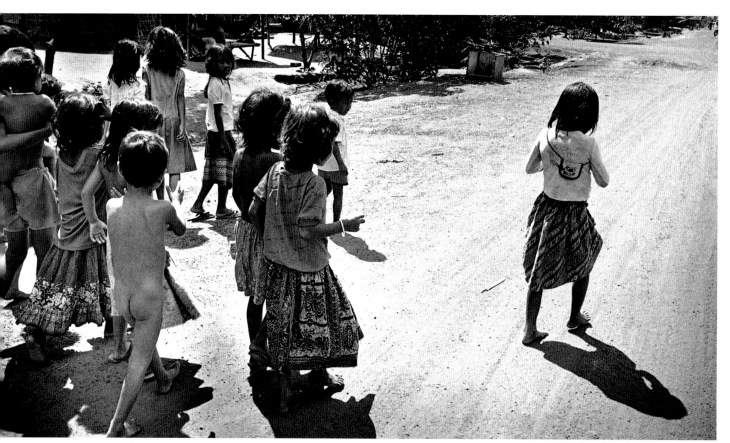

So Than wanders through the camp, taunted by packs of young children. They don't understand what she says, because much of the time she babbles incoherently.

Eleven years old and mentally disturbed, she begs for coins to buy candy or a cigarette. She smokes the cigarette herself, and offers candy to the other children. Frightened by her strange behavior, the startled children let the candy fall to the ground, but they continue to follow her.

She stops by a hut, and an old woman there pleads with her to go home. Instead, So Than walks into the woman's hut, crawls on the platform bed and covers herself with a blanket. She then rolls a cigarette from paper and tobacco she finds, lets the cigarette drop and quickly falls asleep.

The woman is uncertain about what to do with her, so she decides to leave her alone. Soon, So Than suddenly awakens, and continues her journey down the street.

So Than craves water on her skin, and she roams the streets looking for places to get wet. Mud puddles are inviting places to sit and splash. A man obliges So Than by dousing her head with water from a tank. A woman gives her a glass to drink from.

Stopping by a hut where another woman is washing clothes, So Than strips off her skirt and top and asks the woman to pour water over her.

So Than's mother and grandmother have been searching the camp for her, an almost daily chore. They find her sitting in a mud puddle. After a struggle to dress her, they drag her home.

Once back in the dark hut shared by her grandparents, parents and siblings, her grandmother helps her climb up on the bamboo bed and gently covers

So Than with a small wool blanket.

As she has so often done in the past, she ties So Than's ankle to the bed with twine. It is the only way her embarrassed family knows to keep her from running away again.

No one understands what is wrong with her or what to do about it. They only know that So Than brings shame to their family.

So Than sometimes runs away for days at a time, sleeping in the streets at night. She revels in mud puddles, but eventually her mother and grandmother find her and drag her home, where she is tied to the bamboo bed (next pages).

43

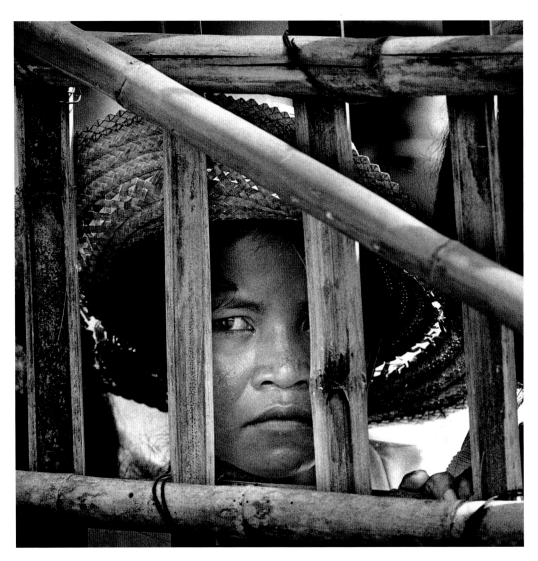

A woman peers through the fence holding defectors from the Phnom Penh government forces. Site 2 residents gather around the cage to look for relatives and hear news of fighting and living conditions inside Cambodia.

DAYS OF HOPING,
NIGHTS OF VIOLENCE

Every morning just before eight o'clock, if all is clear, the same message can be heard on the radios of relief workers waiting to get into Site 2: "Attention! Attention all stations! U.N.B.R.O. security has opened Site 2 for the day. The situation is zero." The gate opens and 240 doctors, nurses, social workers, and teachers from nine relief agencies around the world and 100 U.N.B.R.O. workers are now permitted to enter. Behind them file the water and food ration supply trucks, the lifeline for Cambodian residents of the compound. ■ With their arrival, the tension of the previous night seems to ease. Patients line up at the hospitals. Residents crowd the metal water tanks to fill their water buckets. Markets open for business. Students run off to school. Another day of waiting begins. ■ Within its boundaries Site 2 has begun to resemble a permanent city. With the help of humanitarian relief organizations, Site 2 has hospitals, pharmacies, schools, Buddhist temples, a police force, a justice system, factories that make water jars and latrines, women's associations, libraries, bicycle-taxi drivers, and its own local newspaper. ■ It also has brothels, gambling dens, organized cockfights, skyrocketing crime and corruption at all levels, including a thriving black market in everything from food, books and clothing to drugs and hand grenades. ■ At five o'clock, the relief teams must leave the camp. Twilight merges into darkness and menace. The nights are full of shadows cast by generator-powered bare light bulbs and the flickering campfires that send a pall of smoke into the still air. Pent-up feelings and frustrations turn to anger and violence. ■ As time passes, the people become resigned. They say they see only blackness − no hope.

Ringed by barbed wire and bordered by minefields, the 6.8-square-kilometer camp sits in a no man's land on a flat dusty plain. The camp has no underground water supply and depends for its survival on daily deliveries by more than 270 water trucks from the United Nations Border Relief Operation. Each person is allotted 20 liters of water a day for washing, cooking and bathing, and the arrival of water is a special event.

People who once cultivated their own farms and fed their own children now survive mainly on diets of rice, soy beans and dried fish doled out by the United Nations.

Most of the men are without jobs and face day after day of idleness. The women do chores, shop in the market, cook and try to keep an eye on the children who stray off in fickle coveys to roam the alleys and dirt fields. Boredom is a way of life.

Not surprisingly, the moral fabric of the Khmer has begun to deteriorate. Hundreds of Cambodian men frequent bamboo brothels at night. Many men have taken second or third wives and mistresses, rupturing family life even further. Child abuse increases along with rape, murder, assault and theft.

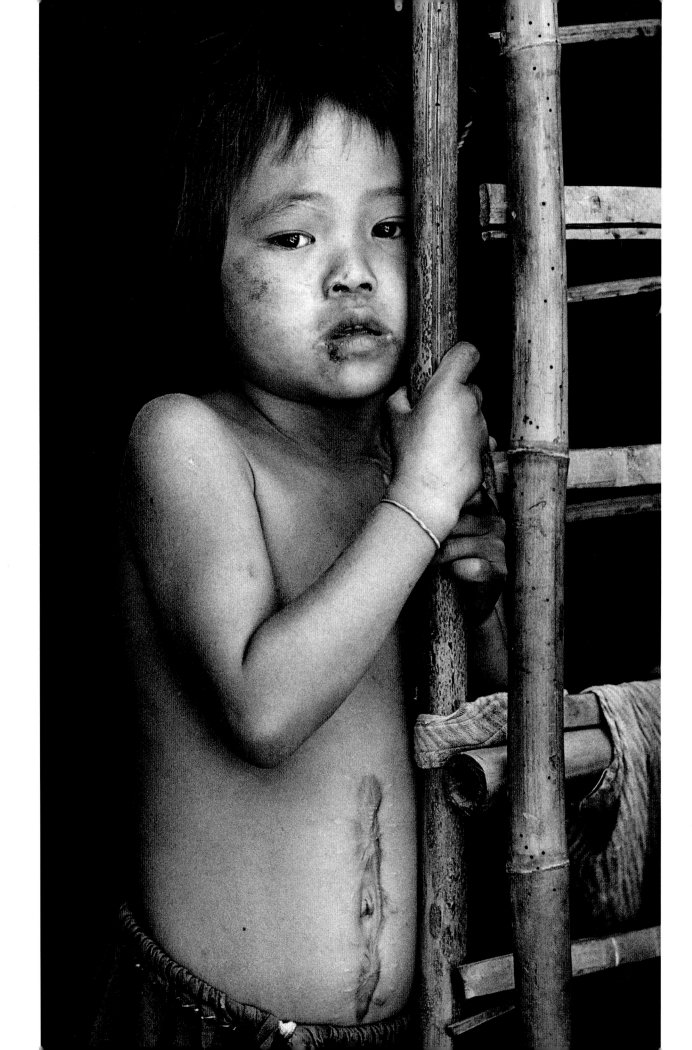

Voung Seanang (left) came to Site 2 after being wounded two months earlier when an artillery shell crashed through the roof of her house. Her family is now among the nearly 200,000 people crowded into flimsy bamboo huts waiting for the time they can safely return home.

This suffocating asylum with its thousands of tiny bamboo huts is the largest Cambodian community in the world outside of Phnom Penh. The war is never very far away, and 1,000-5,000 refugees from the fighting may swell the population of Site 2 every month.

Voung Seanang is a recent arrival. She is six years old. Two months earlier Seanang suffered severe stomach and neck wounds when an artillery shell crashed through the roof of her home in a village 25 kilometers away. Her family fled to Site 2.

Seanang's family, like others who entered Thai territory after 1980, are denied legal status as refugees. Instead, they are officially classified by the Thai government as "displaced persons." As such, they are ineligible for resettlement in a third country.

Meanwhile, Thailand has become uneasy with the increasing numbers of Cambodian refugees. To discourage new arrivals, the government has adopted a policy of "humane deterrence," which includes refusing to move the camps farther into Thailand, away from the daily threat of shelling. Also, no permanent structures or electricity are permitted.

Meanwhile, the camp becomes more crowded with desperate people, who find the jostling mobs a somewhat safer alternative than the random savagery of civil war raging outside the perimeter.

Chhiek Ieng Thai (below) broods about his family, who were killed by the Khmer Rouge. Children and chickens mingle on a dusty Site 2 side street.

Some Khmer have been overwhelmed by war and deprivation. The life of nearly every individual has been damaged by the Khmer Rouge massacres. Chhiek Ieng Thai is 28 years old, and he is lonely and despairing in the midst of Site 2's teeming crowds. Sitting on his bamboo platform, he fingers a borrowed, well-worn English grammar book.

"It's so hard," he whispers. "I live with all these people, but I am alone. I have nothing. I am poor. I can buy no books to study. That would be something to look forward to. They ask me where I go, why I ride my bike all day. I just ride around and around. I can't tell them I do not want to stop to think about my life.

"I have so much pain. I am alone without any parent or sibling to look after me. They were taken to be killed by Khmer Rouge soldiers without doing anything wrong. The problems that happen here remind me to think far away, but I can't tell it to any other. No one here to help me. Now I am homesick very much."

A television antenna (left) stands in contrast to the squalor of a Site 2 pathway, crossed by an open sewage ditch. Bicycles, often loaded to the maximum capacity, are the only mode of transportation for camp residents.

Site 2 reduces all of its residents to poverty. A single tiny, rickety, bamboo hut is sometimes home to as many as a dozen individuals – perhaps three or four generations of a single family. All share the same monotonous diet. Under these conditions, spirits sag, pride in neatness erodes away, and people lose their will to coexist and solve small problems among themselves.

Yet, an underground economy does permit a few small luxuries – perhaps a bicycle that one can share with friends, or even a television set, powered by portable generators or batteries. Power generating is a thriving business in camp. For a fee, any person lucky enough to own a battery can bring it in to be charged. Otherwise, a battery may be rented for special occasions to run lights or a loudspeaker.

Bicycle taxis, operated by soldiers, also are available for hire, unless the soldiers are away at the battlefields; then taxis are in short supply.

There is even a studio where customers can be photographed in front of a large painted canvas of the temple complex of Angkor Wat. The film is processed in a Thai town 100 kilometers away, and prints are delivered within two or three days.

Women file home from the rice distribution point carrying the week's ration on their heads (below). The diet is augmented by dried fish and occasional vegetables. Sitting for hours in the hot sun, a woman clutches a well-worn ration book, vital to her family's survival.

For adults, life at Site 2 is a daily insult. The once-proud Khmer have become welfare clients, living on handouts from the United Nations and various relief agencies. Daily, trucks deliver rice and dried fish to a different section of the camp. After standing in long lines with their ration books, the women finally walk homeward, another week's food allotment balanced on their heads.

Each adult receives 3.0 kilograms of rice; each child, 1.9. Each person is allowed two tins of fish a week, as well as 500 grams of vegetables. The ration also includes two dried fish on alternating weeks, and every 28 days a portion of mung bean or soy bean, salt, wheat flour and vegetable oil.

A woman in a street market examines vegetables for sale (left). A customer enjoys the services of two barbers, both part of Site 2's hustling corps of entrepreneurs.

At Site 2 the high point of each week is the delivery of food, brought in by United Nations trucks. Food becomes currency, and the weekly distribution of rice and beans sets off a flurry of trading activity in a flourishing market based on bartering rations. Schools close for the occasion, and roadside markets open. Precious commodities such as cigarettes, soft drinks, spices, and even vegetables become available, although very expensive.

Donated clothes, cooking oil, mosquito nets and various other necessities are also distributed when they become available.

Without much else to look forward to, most people in the camp live from day to day. They have forgotten what it means to plan ahead, passing the days listlessly in front of their huts, playing cards, minding children and idling away the hours. There is not much left

in which to have faith. Parents who would normally discipline their children for dishonesty now encourage them to steal a few extra handfuls of rice each week.

For many, this dreary pattern of events only reminds them painfully of what they once had. Bandith Thy, a 34-year-old former high-school teacher, is the father of two children.

"My village was only rice fields," he says. "Some coconut trees around the houses only. My house was wooden with a roof of clay. I had two motorcycles, 30 buffalo, 15 cows, 40 hectares for rice fields. The poorest in my village had two buffalo and two or three hectares. Now all we want is to go home and have one buffalo to pull a plow to make a farm."

Thy dreams of going back home someday, where he wants to be a tourist guide at Angkor Wat.

59

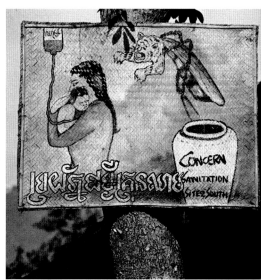

Even though graphic signs warn of polluted water, children play at fishing in a contaminated ditch under a row of tilting outhouses.

The manufacture of the compound's flimsy bamboo and burlap outhouses is one of the rare local industries at Site 2. Sponsored by Project Concern, an Irish relief group, the factory provides a few legitimate jobs. As many as four huts may share a single outhouse, although some of the wealthier residents have managed to obtain one exclusively for their own families.

Despite this rudimentary public latrine system, raw sewage continues to form pools in ditches throughout the compound. These streams are tempting places for children to play.

The warning signs posted around camp by Project Concern graphically depict what will happen if residents fail to boil their water, allow flies on their food, or are bitten by a rabid dog. Despite the warnings, however, disease is commonplace, with widespread cases of respiratory infections, dengue fever, malaria, tuberculosis, typhus, meningitis and diarrhea.

Older boys play basketball in a schoolyard, while younger children pull a small cart through camp. Two boys (above, right) find a high ridge from which to gaze across the camp as smoke from cooking fires drifts over the tops of the huts.

Children seem to be everywhere at Site 2. Nearly half of the camp population is less than 14 years old. Twenty-six percent are under 4 years of age, and 7 percent are less than one. Many of these children have lived their entire lives behind barbed wire – a new generation of farmers' children who have never seen a water buffalo, a rice paddy or a river.

Although many children attend school, there is little else to do besides care for younger brothers and sisters. They wander restlessly through the streets just to pass the time, or else play an occasional game of basketball or soccer. Packs of young children, many of them naked, scurry through the back alleys, sit in the shade of their huts, or play in the dirt fields.

For thousands of teenagers, the harsh reality of life in a detention camp is that they have little entertainment or any real jobs to which they can apply their schooling. Mostly, there are idle hours.

Many have bad dreams, like 19-year-old Oum Kheama. What if shelling happened when she was at school? Would she ever find her parents?

Pol Pot has already devastated the rest of her family. "It makes us so afraid," she says. "I wish the boom-boom-boom at night would stop. For all time."

A crowd cheers two former soldiers in a one-legged race. Sponsored by the handicap workshop, the events also included races for workshop-built wheelchairs and prosthetic legs. The camp is home for nearly 3,000 war-wounded.

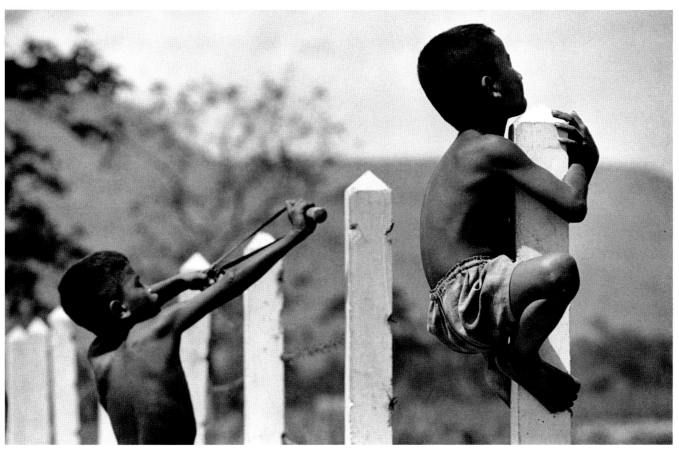

Signs of war are present everywhere– in the concrete bunkers, in an unexploded Soviet-made 107-mm. artillery shell that landed in camp during a New Year's celebration, and in the mock battles of small boys armed with slingshots.

Separated from the Cambodian border only by a narrow ditch 30 meters away, the Site 2 compound is always close to the war. Muffled booms of artillery fire resound off the nearby Dangrek mountains at night. Residents toss in their sleep and awaken from nightmares. In reality, the threat of shelling is as much a part of camp life as queuing up for food and water.

When danger is imminent in the daytime, the residents watch silently as the foreign relief workers, heeding the warnings on their two-way radios, begin to file out of the camp to safer ground. At night, when enemy troops get near, rocket mortars can rain down on the camp without warning as they did during a recent festival, killing or maiming scores of people.

After the attacks, hundreds of people huddle at the barbed-wire fence, hoping to escape. In calmer moments, small boys play war games at the perimeter, shouting brave insults at unseen enemy soldiers outside the barbed wire.

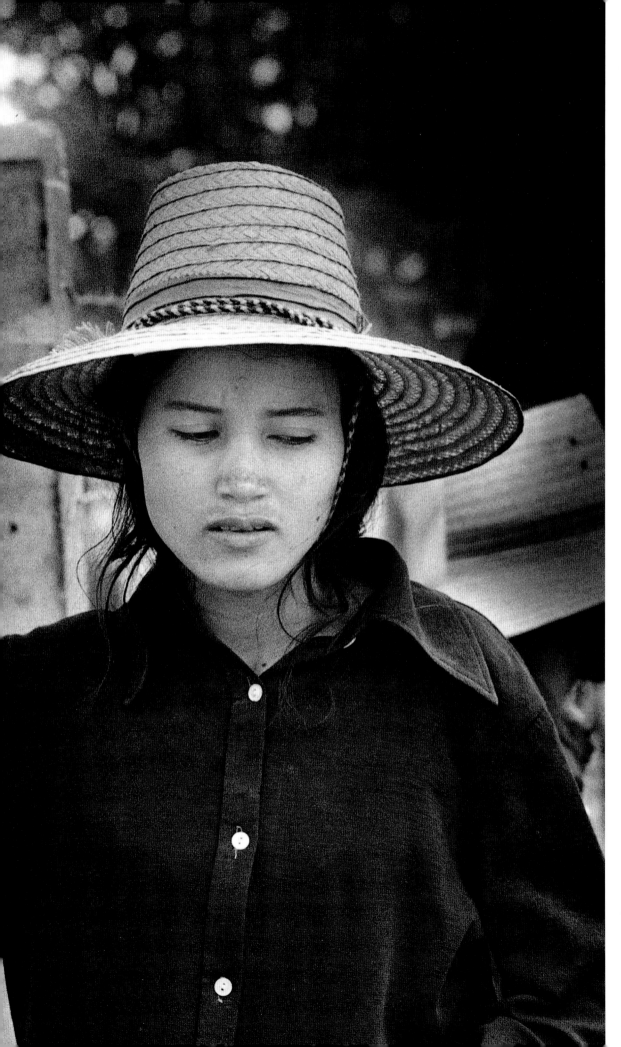

A young Khmer woman lingers at the barbed-wire fence marking the boundary of the camp. Many residents of Site 2 feel trapped, complaining that they are like "chickens in a cage."

Thai officials and guerrilla leaders dictate that all foreign relief workers leave the camp every day by five p.m. The camp reopens at eight o'clock the following morning, after United Nations Border Relief Operation security has made certain it is safe to enter. The Thai Protection Unit checks every person in and out in order to know who is still in camp in the event of an emergency evacuation and to make sure that everyone leaves.

Threats of danger during the day may clear the camp of relief workers. Situation "0," all is calm, frequently elevates to Situation "1," indicating the possibility of danger, perhaps from distant shelling. Situation "2" is announced if the shelling or gunfire occurs within two kilometers of the camp perimeter; all relief workers must evacuate the camp except for emergency medical teams. Situation "3" is a signal for all relief workers to leave immediately, because artillery shells are falling very close to the camp. Situation "4" means extreme danger, such as artillery shells falling inside the camp, and is a warning to take cover wherever you are.

Despite the dangers inside the camp, few Khmer are willing or able

A young boy (left), wearing a cape made of a rice bag, runs along the perimeter of the camp past a trash fire. Nearly 1,000 people lose limbs to land mines each month inside Cambodia and along the border. The barbed-wire fence serves as a clothesline for a family's laundry, but at night it offers no protection against marauding bandits.

to flee Site 2. For most, the fenced perimeter is the edge of their world. Those who do venture beyond the barbed wire to scavenge for food and precious firewood must gamble against the thousands of land mines in the area. Planted by troops on all sides of the civil war, the mines explode so often that residents have developed a keen ear for the difference between the heavier boom of antitank mines and the sharper blasts of antipersonnel mines.

"We understand that. No problem," a resident explains. "It happens every day."

The sound of an explosion can also announce the death of someone who has inadvertently stumbled over a mine. People entering or leaving the camp frequently set them off, and residents who have lost arms and legs to mine explosions are a common sight in the compound. Some were maimed on the treacherous journey to reach Site 2 in the first place.

There is a workshop in which victims, mostly former soldiers, can fashion their own prostheses, but the loss of a limb only deepens feelings of uselessness and the fear that normal life is gone forever.

71

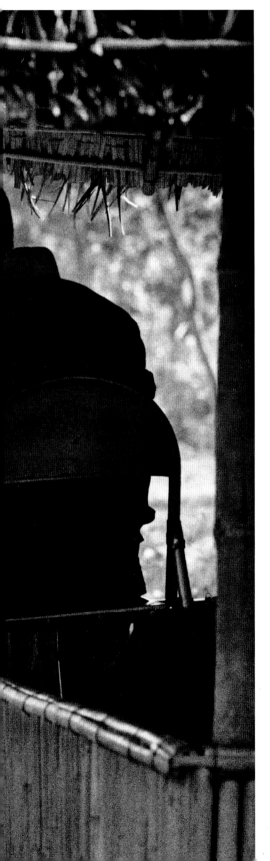

Thai Rangers of Task Force 80 intimidated, and sometimes struck women and children at the north-south checkpoint. Andy Pendleton (right), U.N.B.R.O. field coordinator, helps with residents' problems. A Red Cross van (below, right) and all foreign relief workers must check out by 5 p.m.

For a time, Thai rangers of Task Force 80 guarded the internal security of Site 2. Once, they patrolled the camp, attempting to keep order by terrorizing the residents. At the checkpoint between the north and south sections of the camp, where the Khmer could cross only for eight hours on Sundays, the rangers often insulted and even intimidated women and children.

Finally, after too many reports of beatings, rapes, and murders by the rangers, Task Force 80 was dismantled and replaced by the Displaced Person's Protection Unit, which has been instructed to treat the Cambodians with more respect and is considered a great improvement.

The checkpoints are now manned by Khmer police, who permit free movement back and forth between north and south, but problems continue because the age-old ethnic tensions between Thais and Cambodians will not disappear soon.

Recently, 10 Khmer women have complained that Thai Protection Unit guards rounded up their husbands after dark and beat them severely in retaliation for an incident in camp the day before.

A woman breastfeeds her baby while waiting with a battered wife for emergency treatment at the American Refugee Committee Hospital (right). Both were assaulted by drunks. At night, mostly men gather at shadowy roadside bars.

At five o'clock in the afternoon, when the relief workers leave, Site 2 perceptibly changes into a different place. As darkness falls, people move eerily in and out of the long shadows in the streets and markets.

The threat of shelling attacks on the camp is greater in the evening, and many families pack bags of belongings in case of a sudden evacua- tion. There is a nervous, uncertain air among the Khmer as the dirt roads begin to empty. Mothers keep a close eye on their children, and fathers watch the streets for any signs of violence. Many hospital patients leave the hospitals, carrying their IV bottles, for the relative safety of their huts and family.

Roadside bars and brothels open.

The video parlors come alive with martial-arts films and Indian romances on the flickering screens. Mostly, it's the men who go out. Few women venture into the night.

Nighttime arguments can turn violent. The camp's three hospitals begin to collect the evening's harvest: victims of child abuse, wife beating, drunken brawls, and simple brutality.

At the American Refugee Committee Hospital, an injured man is comforted by his mother. A drunk man hit him with a stick, and his friends tried to stop the bleeding with a bandage. A mother with a young child says that a man came looking for a "taxi girl," and when she protested that she wasn't a prostitute, he hit her across her head with a root, ripping her ear.

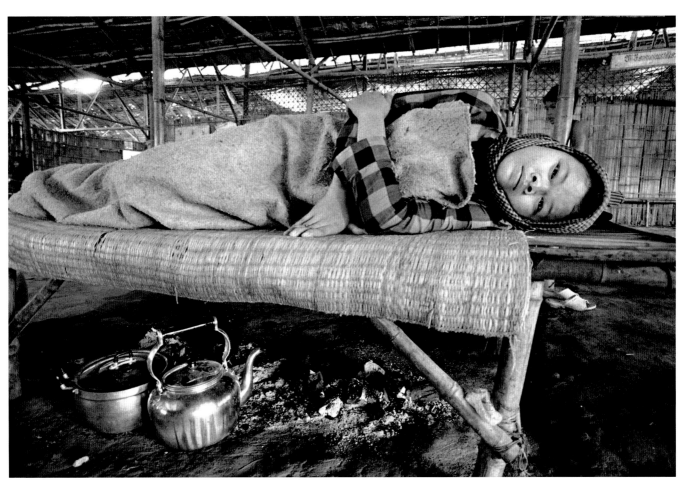

A mother who has just given birth at the American Refugee Committee Hospital is wrapped in blankets and rests over a bed of coals in the traditional Khmer treatment to correct the imbalance of hot and cold within her body. Western doctors agree that there may be some benefit from heating, which is believed to shrink the uterus and increase circulation.

A HEALING MIXTURE OF MAGIC AND MEDICINE

L ike any city, Site 2 attempts to care for the sick, the infirm, the crippled and the dying. Every year, thousands of people with symptoms ranging from stomachaches and fever to severe psychological and physical trauma seek urgent help. They may get it from doctors in one of the three Western-run hospitals in the camp. Or they may be treated by a traditional krou Khmer healer, who uses herbs or massage. Some may seek a primitive, mystical "bang bot," a practitioner of a bizarre form of black magic based on supernatural powers, superstition, spells, magical water, and healing gifts. ■ As a result, medicine in Site 2 is an uneasy alliance of rural Cambodian folk medicine and Western science. Western-trained doctors could diagnose and treat each patient, but their goal instead is to train Cambodians to heal and treat each other – "Khmer self-management." In the process, the Western techniques have merged with traditional treatments. Western doctors, in coming to respect the krou Khmer, have recognized that they themselves cannot always cure patients with methods the patients do not believe in and that patients sometimes respond to treatments that may seem unscientific. ■ Tragically, the Khmer sometimes cling to traditional treatment so long that they are beyond the help of Western medicine. But in a camp with limited resources, the art of healing has of necessity turned into a blend of ancient folk wisdom and modern technology. The result is a new approach to medicine, which those Khmer trained at Site 2 will likely take back to Cambodia when peace finally returns.

Dr. Jim Kublin, an American, holds a tiny patient in the pediatric ward of the Catholic Organization for Emergency Relief and Refugees Hospital (left). Dr. Louie Braile makes his rounds with Khmer medical students at the American Refugee Committee Hospital, stopping to see Kun Phyrum, age 3, a suspected polio case.

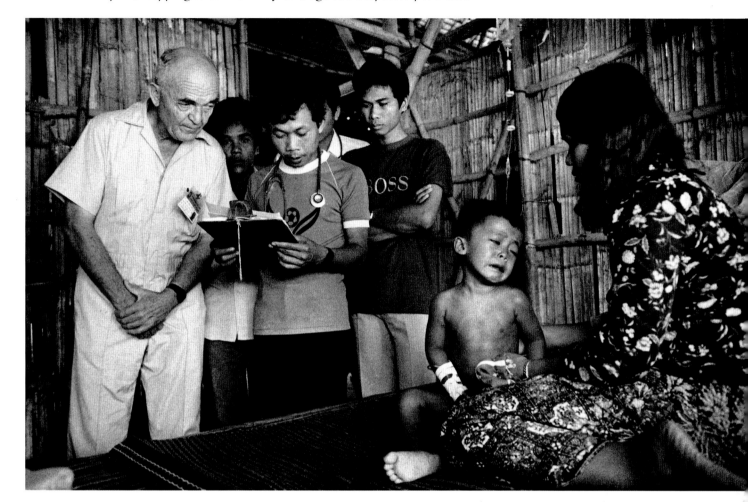

To the rural Khmer, a hospital can be an alien, frightening place. And the chasm between Western medicine and traditional Cambodian healing practices is often wide – where a Westerner identifies heartburn with increased stomach acid, a Khmer healer may blame evil spirits for putting glass in the stomach.

Nevertheless, a cultural translation of the glass-in-the-stomach complaint may provide a critical insight to a Western physician such as Jim Kublin, an American physician at the Catholic Organization for Emergency Relief and Refugees Hospital at Site 2. Kublin has worked to establish trust with krou Khmer healers in order to benefit from their special skills.

At the American Refugee Committee Hospital, patients will see Dr. Louie Braile, an American physician who has been coming to border camps since 1980. When he first arrived, he dealt mainly with injuries, acute diseases and starvation. Today, he trains Cambodians to treat and heal their people, laying the post-war groundwork for their own medical-care system.

Each morning "Papa Louie" makes his rounds with Cambodian medical students, challenging them to make their own diagnoses and to prescribe treatment for the patients.

There is no advanced medical equipment or a luxurious array of antibiotics. Since Cambodian medics will not have these in jungle clinics, they are not used in the hospitals. "Except for antibiotics and intravenous capabilities, it's like practicing in the early 1900s," Dr. Braile says.

A Western doctor and Khmer medics sew up a head wound on a soldier who was injured in a drunken fight while on holiday leave. The other soldier was taken to a different hospital with a stab wound in the chest. The only lights in the hospital are powered by truck batteries.

A girl tries to feed her younger sister (below), a bronchial-pneumonia patient at the A.R.C. Hospital. In the sticky heat, Ka Sarmon fans his malaria-stricken son, Mon Sophea. While malaria has been virtually eliminated in the Site 2 camp, Sophea caught it on the battlefield and tradtional Khmer treatments failed to help him.

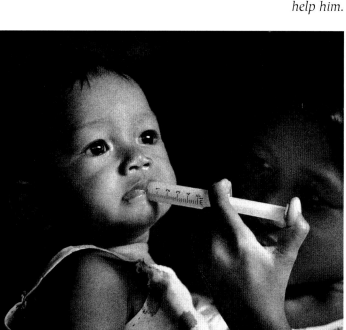

At a Site 2 hospital ward, patients sleep on narrow bamboo beds. Children and dogs wander from one room to the next, and chickens peck at the blood on the dirt floor underneath beds.

Many patients request intravenous injections because it seems like a more serious treatment than simple bed rest and plenty of liquids at home, so the hospital often obliges.

Anxious for a cure, the patients sometimes buy black-market pills and take them indiscriminately according to color. Red pills are considered most powerful.

Sometimes the gap between Western medicine and traditional healing can be too wide. Recently, a 19-year-old man was carried into the hospital on a "saeng," or hammock-like stretcher. Mumbling and disoriented, the patient was nearly comatose.

82

Covered with the auspicious tattoos of a Khmer warrior, his body bore the marks of traditional Cambodian treatments – reddish-purple cupping circles on his forehead and coining streaks on his torso.

Doctors immediately diagnosed the man as having cerebral malaria, but despite prompt intravenous treatment, it was too late to save him. He died six hours later.

A continuing flow of patients with malaria, congestive heart failure, tuberculosis and strep infections arrives at the hospital. There also has been a serious cholera epidemic.

But the greatest increase in cases has come from victims of violence. Often, the hospital can seem like a M.A.S.H. trauma unit as battered women, stabbing victims, and men injured in fights by axes and chunks of firewood come in for emergency treatment.

83

When the Vietnamese troops ended the carnage of Pol Pot's Khmer Rouge in 1979, the United Nations reported that only 45 doctors, 26 pharmacists and 28 dentists survived. Uong Saroeun is hopeful that his certificate from the A.R.C. medic program will be recognized when he returns to Cambodia.

On a typical morning, Uong Saroeun will check patients for signs of fever and internal bleeding, work with Dr. Braile on the diagnosis of a possible polio case, update fellow medics on the treatment of malaria patients, and in general, be a leader of his people.

Shy and soft-spoken, Saroeun is the chief Cambodian medic at A.R.C. Hospital. He came to the border in 1982 looking for a better school. "My father and my mother, everyone wanted me to be a soldier, except me," he says. "I wanted to be a medic."

The instruction is hard, he admits, but he has persevered, studying from United Nations medical handbooks and learning pathology, anatomy and physiology as well as how to take charge in an emergency and how to help with an operation.

Most Cambodian doctors were killed by the Khmer Rouge. "When I am finally finished," Saroeun explains, "my job will be to train others, so there will be more of us."

Saroeun, age 29, feels that the krou Khmer can play an important role working with a medical team, although sometimes, he confesses, their treatments can be harmful.

"It makes me feel very sad when I see the injured here," he says. "They are in pain, and to me it is as if my entire family was in pain."

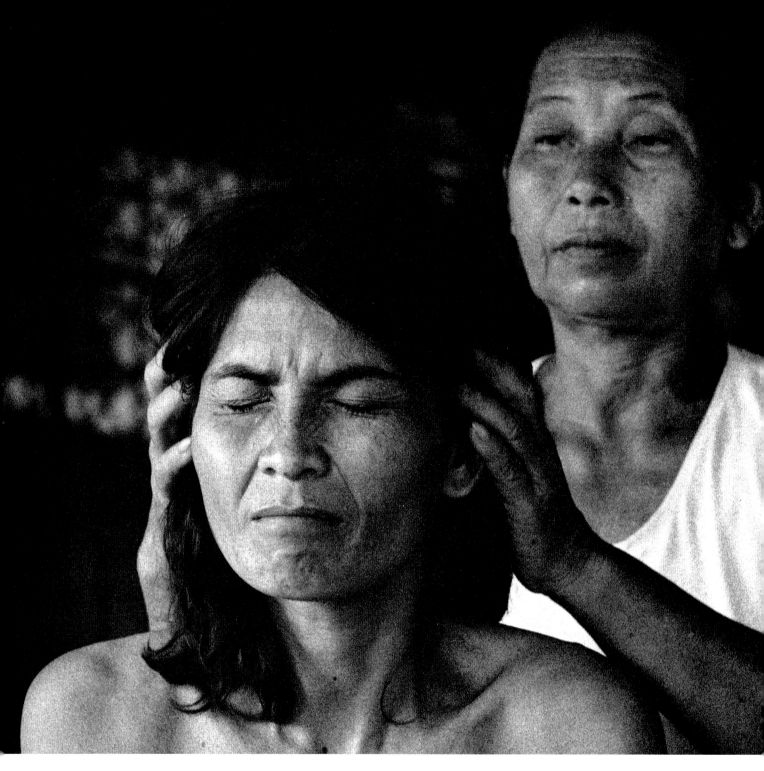

L im Heang has been a krou Khmer
for many years, practicing tradi-
tional Cambodian methods to heal a
broad range of complaints that do not
always fit neatly into the diagnostic
categories of Western medicine.

Trenh Hey, for example, came to
the Khmer People's Depression Relief
Center complaining that she cries
constantly, feels dizzy, and suffers
from headaches.

The 40-year-old widow of a soldier

killed during Pol Pot's time, she has
three children. Her bamboo hut re-
cently collapsed, and she had no one
to build a new one. The Center offered
temporary shelter, and Lim Heang
treated her symptoms with "coining,"
a firm head massage, and a spinal
adjustment.

In coining, or "koh khchal," which
means scratching away the bad
winds, a small coin dipped in kerosene
is rubbed on the arms, back and chest,

Lim Heang, a krou Khmer, massages the head of patient Trenh Hey, who complained of dizziness, headaches and depression (far left). Coining is done with a small coin dipped in kerosene (left). Below, some of the dried roots, herbs and bark that are used in various combinations with alcohol to treat a wide range of illnesses.

producing a warming sensation and leaving bruise marks.

Coining is used to treat a wide assortment of ills ranging from mild to serious. Pressure is applied along the meridian points used in acupressure, and even Western doctors admit that it sometimes seems to work.

Dried roots, herbs, and bark – 126 types in all – are used by the krou Khmer in various alcohol-based elixirs to treat rheumatism, urinary-tract infections, and polyps, among other complaints. These jars of bright red, orange, yellow and cinnamon-brown medicines also are given to patients suffering from a widespread ailment – weakness.

Western doctors like Jim Kublin have come to accept the efficacy of some of these methods as a first line of treatment, but they believe traditional ways should often be used in conjunction with Western technology.

Som Sokhan, a "srey boromey," treats Sman Yam for stomach pains. Treatment begins by reading cards and chanting by candlelight in front of a green wax deity and a fuzzy orange pony bank. Sokhan also says she can cure the lovelorn with magic called "dak sneh." When a heartsick man wants a pretty girl to love him, she offers a special wax - a combination of ear wax and urine - and chants over a diagram to cast a spell.

Som Sokhan calls herself "srey boromey" or magic woman. Magazine advertisements cover the walls of her hut, and above her altar of artificial flowers, candles, and a tub of burned pink incense sticks, orange and yellow streamers hang from the ceiling.

One of her three patients this day, 51-year-old Sman Yam, says she was in the hospital nine days with stomach pains but did not improve.

She claims doctors told her she has only six months to live, and friends had urged her to come to Sokhan.

The boromey begins her treatment by conjuring up her "elf shadow" with burning incense and reading well-worn playing cards by candlelight in front of a green wax deity and a fuzzy orange pony bank.

Entranced, Sokhan chants in an ancient tongue, which she claims not to know, and begins to scribble with great flourish. Her elf shadow tells her how to treat the patient.

She spits "magical water" while writing the strange hand on Yam's back with the ends of burning incense sticks.

A group of young women wait to consult another magic woman, a "bang bot" named Heng Leap, not to be physically healed, but to get prayers to protect the lives of their husbands on the battlefield.

Heng Leap learned she had the "powers" after the Khmer Rouge took her with others in her village to the field to be killed. A soldier struck her on the head with a stick, and she fell into an open grave landing on top of bodies. As she was about to be buried alive, a big gust of wind blew away the suffocating dirt and lifted her skinny body into the sky. When she awoke, she was safe in the jungle.

Sometime later she was stabbed through the heart (as proof, she unbuttons her top to expose a long scar), then tied up inside a burlap bag and cast again on top of a mass grave. Once more, the wind blew off the rope fastening the bag, and blew her into the clouds.

Since then she can recognize when people have a black magic spell cast on them, and her spirit can fly to see men on the battlefield and protect them from injury.

Hout Kim (left), 66 years old, and her sister Hout Him, age 68, both lost their husbands during the brutality of the Pol Pot years. Kim's head is shaved for a Buddhist celebration.

THE QUIET PASSING
OF ANCIENT WAYS

T he secret world within a secret world belongs to the elderly at Site 2. Thousands of children play in plain view; teenagers stroll down the roads; and adults stream into the marketplace. But the nearly 5,000 old people are virtually invisible. ■ For the elderly, life at Site 2 is mainly a collage of memories from the old days – a world of quiet bamboo villages, green fields and streams plentiful with fish – mingled with despair of ever seeing Cambodia again. Many of them spent their lives as farmers, as did their ancestors as far back as anyone knows. ■ Most live on the fringes of camp life, cut off from all the others. Some are infirm and depend on regular visits from outreach workers for food and medicine. Others take sewing classes, and a few take refuge in a special center set up by Buddhist monks. ■ Some of the old women spend hours at the Khmer Women's Association, spooling colorful threads, making sarongs and scarves on looms and weaving baskets – Cambodian arts and crafts traditions passed down from mothers and grandmothers. But for most, life at camp is depressing and filled with grief. Many of the elderly have lost all of their children to Pol Pot and have no connection with the future, no family structure to which they can cling. ■ Even if the war were to end soon, it would be very difficult for the old people to return to their native land, ravaged by years of fighting. Without a family to care for them, how would they survive? Who would provide food, shelter and medical care in the middle of the jungle? Yet, for most of them, dying in a foreign land is worst of all.

Seventy-nine-years old and nearly blind, Nuon Soum moves slowly in the midday heat on her way to visit a friend. She fled Cambodia to the border camps in 1979.

Two sisters live together quietly with their daughters at the far north edge of Site 2. Hout Him is 68 years old, and Hout Kim is two years younger. Their house is a neat little bamboo hut shaded by banana trees they planted themselves when they first came to the camp several years ago. Before they came, the Khmer Rouge killed both of their husbands and the husbands of their daughters.

Deep in the shadowy interior of the hut, Hout Him's 14-year-old grandson swings on a hammock. For hours he laughs to himself, or shouts "the house is burning." Sometimes he barks like a dog or screeches, amusing the children who peer at him through slats in the bamboo wall of the hut. Nobody understands why he acts that way, except that he went mad during the Pol Pot years.

Nuon Soum is 79 years old, and she has severe arthritis pains in her knees. Her tiny hut, with an area of only two meters by three meters, has no standing room, only a bamboo platform that is bed, table and chair in one. Her last surviving relative, a son, brought her to the refugee camps, but died several years later from drinking too much.

"It's very hard for me," she says. "It's very tiring, and I worry about my eyes. I cannot see well. If there was trouble, what would I do?" She worries that thieves may break in and steal her few meager possessions.

"I have to take care of myself, but I like it here," Soum says, sliding slowly from her mat and standing up outside her door. Dressed in a tattered purple sarong and a white blouse, she clutches a walking stick and a rice bucket, and slowly makes her way down a road deserted in the midday heat to visit a friend.

One of the traditional family roles for elderly women in Cambodian society is to pass down skills such as weaving. With their families lost, they now weave gift items at the Khmer Women's Association.

Traditionally, in Cambodia the elderly are venerated for their wisdom. The survivors at Site 2, having lost most or all of their relatives, are denied their historic family roles and places in society. They can no longer pass down their skills – such as weaving and basketry – to future generations.

Today, at the Khmer Women's Association, elderly women spend hour upon hour weaving and sewing, exercising the arts taught to them by their mothers and grandmothers in their home villages. Many of the items they make will be gifts for visiting dignitaries or will be sold in the Association's gift shop.

The old men, often idle and depressed, are encouraged to carve toys for children. For some, this vocation gives them a reason to live and a feeling that they have something to contribute to the community.

A special village for the aged has been set up next to the Buddhist temple, where elderly people can take refuge. There pious old women can become "yeay chis," nunlike assistants for the temple. They make up the chorus, cook for the temple, and help with weddings and funerals by chanting and bringing food.

Khan Vang, age 68, had been a farmer all his life in Cambodia. Now he has only a small garden patch, which he cleared from the minefield outside the perimeter fence.

'I have always been a farmer," says Khan Vang. "My father and grandfather were farmers. All farmers for a long time."

Now, at Site 2, Vang tends a garden 15 meters square, but slyly he keeps expanding it. As it grew in the direction of Cambodia and the minefields, he ripped down part of the barbed-wire perimeter fence to clear more soil and make room for the tomatoes, long beans and cabbage that he grows. They add variety to his diet and that of his eight married sons. Sometimes he has enough left over to sell at the market.

Vang is now 68 years old and has lost his wife. "Life is better at Site 2," he says. "I am very old and want to stay here." Like the other old people, he would face an uncertain existence if he returned to Cambodia. Here, at least he gets free food, shelter and medical care.

There is only one thing he wants, Vang adds, as he rests from tending his patch of earth at the edge of camp. Gazing out to his native land, visible across the clearing less than a kilometer away, he says: "I want to go back to Cambodia to die."

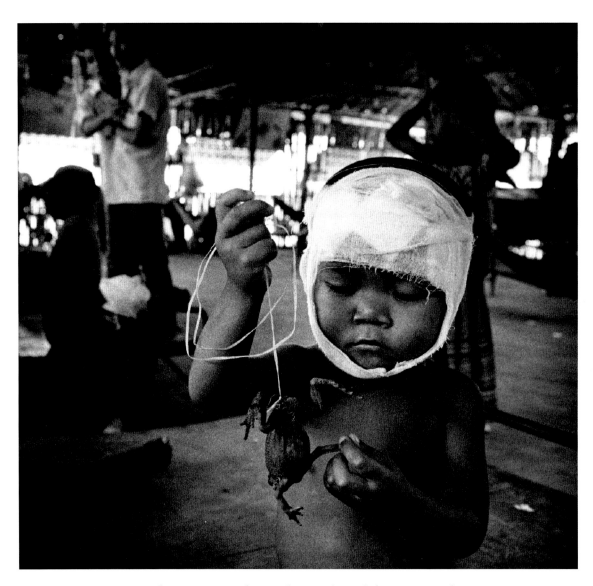

Toun Channy, age 4, plays with a pet frog while recovering from pneumonia and surgery at one of Site 2's three hospitals. His medical records read, "never gone out of this camp." Like most children at Site 2, the border camps are the only home Channy has ever known.

THEY DO NOT KNOW
THE WATER BUFFALO

The children who swarm through the streets of Site 2 and poke along the barbed-wire perimeter are a lost generation. If the elderly have been deprived of their culture, the young have never had one. Most of the children in the camp were born without a homeland and only a war for a legacy. Today they are growing up on the Thai-Cambodian border where artillery shelling, rationed food, and fighting are a way of life. ■ Children of the camp have few role models. The Khmer Rouge massacres in Cambodia destroyed many families. Even where there are enough kinship ties left to pass along ancestral wisdom and experience to the young, there is little reason to do so. Their parents and grandparents survived through a knowledge of farming or of craftsmanship passed down from one generation to the next. However, there are no farms in camp, only a few small garden patches. Now the only skills that can be taught to boys are those of soldiering, while girls learn to sew, launder clothes, prepare food and tend younger siblings. ■ The children in Site 2 know only that rice and water are delivered by a truck and that buildings are rickety bamboo huts. Many cannot even imagine a rice paddy, a water buffalo or a fisherman's quick dexterity with a net. In camp, survival may mean sifting spilled grains of rice out of the dirt or cheating and stealing to get food. ■ "They receive everything from the United Nations Border Relief Operation," says Nuon Phaly, director of the Khmer People's Depression Relief Center. "They think rice comes from the back of trucks. They do not know rice is grown in the fields."

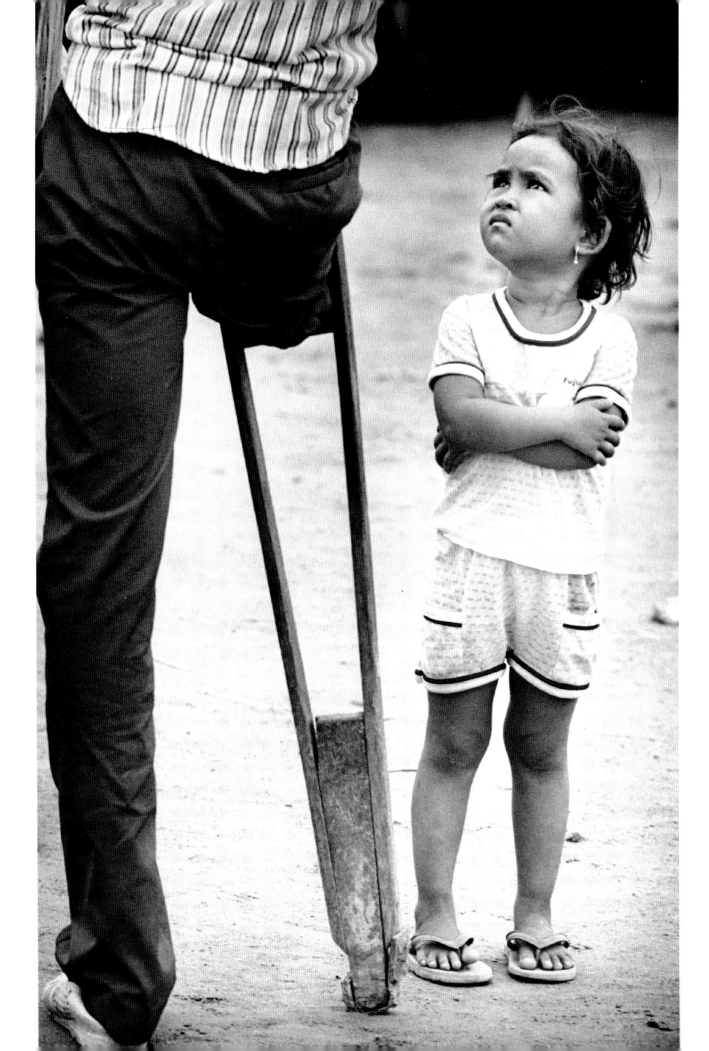

A young girl looks up at her handicapped father, a former soldier who lost his leg to a land mine. Children (below) hold hands while strolling along a dirt street.

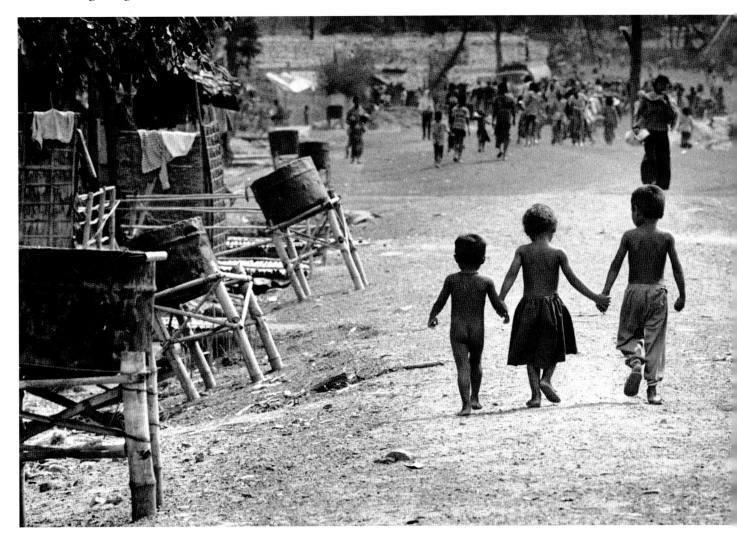

C hildren are everywhere in camp. Filthy, wearing torn and soiled clothes – or nothing at all – they wander in packs through the dirt and squalor of the streets. Some children chase a relief truck down a dusty road. Boys splash and play in a murky, polluted canal. A young girl inspects herself in a chip of a mirror as her mother picks lice from her hair. On the street, they stop and look at almost anything out of the ordinary.

Some children, especially girls, are as young as five or six years of age when they are taught to care for smaller siblings.

Many children are raised without a father, who usually is away fighting in the resistance or has already been killed in the civil war.

Soldiers often come into camp to visit their wives and children during the holidays or on furlough every three to six months. Others retire permanently to camp after being wounded in the fighting. Children are accustomed to the sight of men with one or both legs missing.

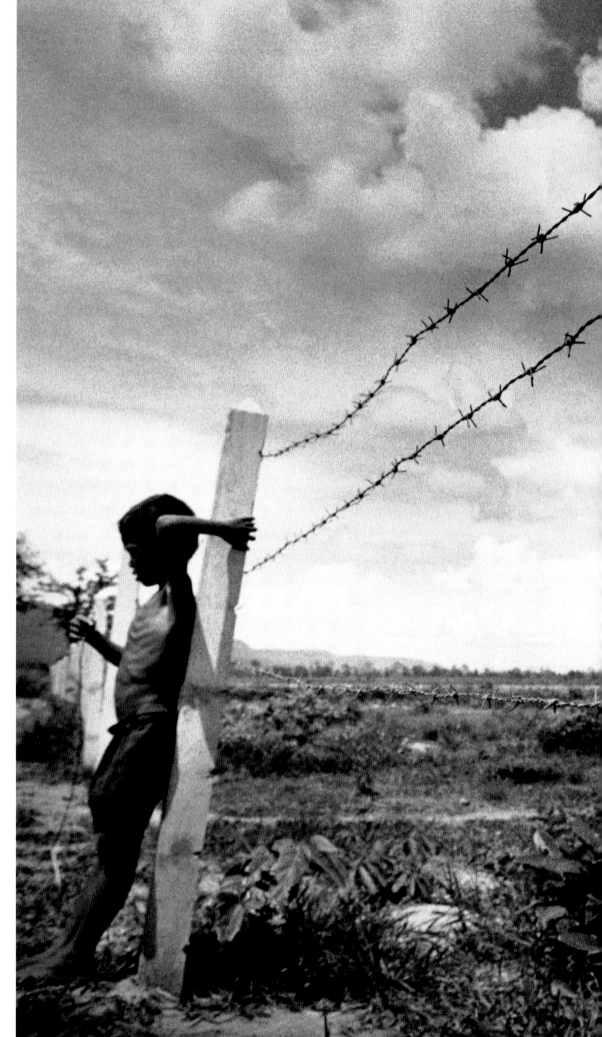

Nine-year-old boys play a game of war at the perimeter barbed-wire fence, firing their slingshots and shouting threats. The enemy, though out of slingshot range, is real enough – the boys can hear the artillery fire nearby.

Children play with a homemade popgun (below). Twelve-year-old Chheng Kosal draws a familiar scene – medics rescuing a wounded soldier and carrying him to a border hospital.

Children in the camp laugh and play naturally, but they take their cues from the war and violence that permeate their environment.

Like their parents, the children are eyewitnesses to theft, murder, assault and rape.

At the Dangrek Primary School, 10- to 12-year-old pupils keep small notebooks of drawings they make during class. Some draw what they see in their imaginations – an idyllic homeland they have never seen, with wide blue streams, lush green trees and a sun with long yellow and orange rays setting over the distant, pristine mountains. Lonh Sokha, age 10, carefully draws pink and red blossoms in a flower pot next to a bamboo house on stilts. She has never seen her home in Cambodia, but she knows "it was very beautiful."

Others draw what they know – scenes of war and violence. One child sketches soldiers armed with machine guns rounding up prisoners. Chheng Kosal, age 12, draws medics rescuing fallen soldiers and taking them to a border hospital. Chea Som, age 12, draws himself alone amid row upon row of bamboo huts.

A father tells how his seven-year-old son pointed to a picture in a magazine and exclaimed "Chke" (dog)! "It nearly broke my heart," the father said. "He did not know the water buffalo."

A little girl takes a bath in a bucket (left), and young girls, already taking on women's traditional roles, wash clothes in a muddy reservoir (below) while boys splash and play.

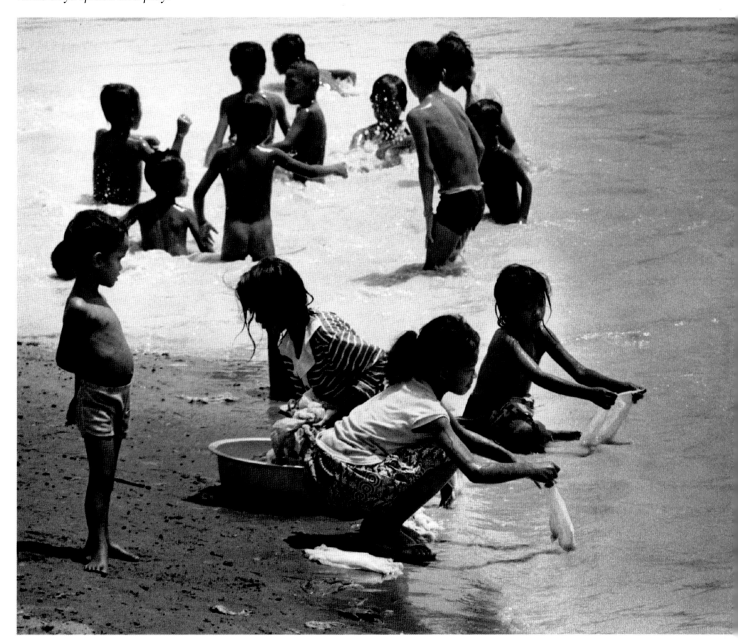

Children know no other way of life except the one dictated by the cramped conditions of the camp – tiny houses, strict food and water rations, unsanitary conditions and a lack of privacy. In this setting, sex roles are formed early.

Little girls learn to help with household chores, including basic cooking, washing clothes, and sweeping the dirt floors. By the time they are 10, they go to the market, collect firewood and food rations from the distribution center, and carry heavy water buckets. Most girls start school by the age of six or seven, but few advance beyond the primary grades.

Young boys – unable to learn how to cultivate and harvest a rice paddy or how to tend water buffalo or oxen – go to school or hang out in the streets with friends.

Children learn to scavenge early. Boys check trash for paper and plastic (below). A girl carries home the family's allotment of firewood (right), and six-year-old Bun Hang sifts dirt for stray grains of rice in the distribution area (below, right).

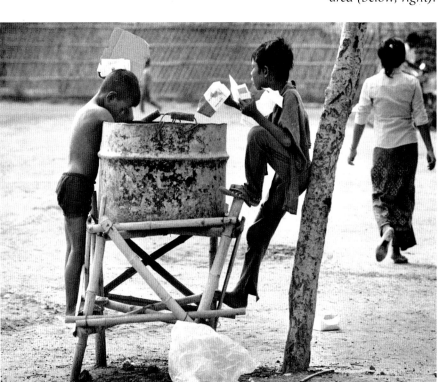

F uel and food are precious at Site 2. Virtually everything is recycled or consumed. Parents send their children out to scrounge in the trash cans for plastic or paper to burn. The paper trash supplements firewood, which is rationed at three logs for each family every two weeks. Plastic bags are sometimes melted for oil.

Children of poor families sift the dirt at food-distribution stations for spilled grains of rice. Rice is practically a currency, traded for almost anything from cigarettes and vegetables to transistor radios and illegal hand grenades, which sell for about 12 baht, equal to 50 cents in American money.

Some parents teach their children to steal food. If the family is very poor, they may send a child to beg for money or food from people on the street or at the hospital.

Both adults and children sometimes take their chances in the minefields outside camp to cut some extra firewood inside Cambodia.

In 1975, the Khmer Rouge separated parents and children by sending them to mobile work camps. Due to the destruction of the family unit and widespread famine, few babies were born. The declining birth rate is reflected in the smaller number of 12- to 16-year-olds in border camps. Due to a population explosion in recent years, 40 percent of the camp's population is now under 10 years old.

After an unsuccessful attempt to steal rice from the distribution center, a boy is beaten by his older brother and ridiculed by other children.

Even for the children, life at Site 2 is predictable and boring with only empty days stretching ahead. Waiting for hours in the hot sun for something to happen, like the arrival of a food-distribution truck, can turn games into mischief and violence.

"The children always see their parents fighting," says Nuon Phaly, a Cambodian counselor. "They look so sad. In Cambodia, I never see this – only in this camp."

The children seldom if ever see the many animals native to Cambodia, only the camp's luckless dogs, pigs and chickens.

Ros Wanna describes his six-year-old son Banath's reaction to his first fresh fish bought at a market: "When we brought the fishes home, my son said 'What is this Daddy?' And I said, 'This is the fish.' He is afraid of the fish." Crinkling up his nose to imitate his son, he says, "'It has a tail and eyes. What do we do with it?' I said, 'We eat it.'" After the fish is cooked and served, Banath is afraid, but his father forces him to eat. "After that, he likes it very much."

Sometimes, Wanna takes Banath to the barbed-wire fence surrounding the camp, where he sees the Thai chasing oxen and water buffalo. "He jumps up and down," says Wanna, "and yells very loudly, 'That is a very big animal!'"

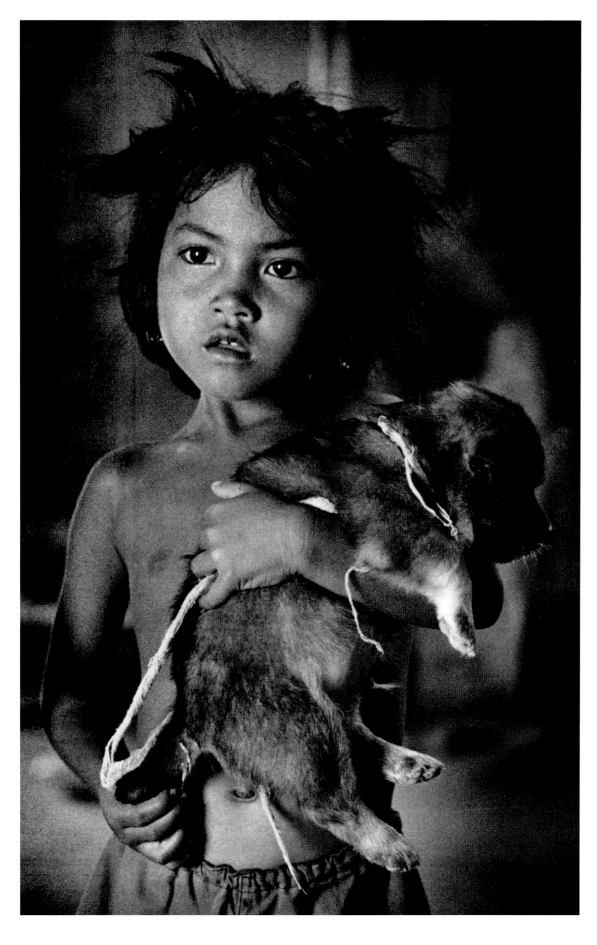

Children treat animals and each other with indifferent cruelty. A boy kicks his dog and a girl clumsily holds her pet. Dogs are pets during the day, but play a more important role in famliy security after the sun goes down.

Toys are rare in Site 2, and children must be creative to entertain themselves. Pebbles in a can make a rattle. Rubber bands stretched across tuna tins impaled on wooden sticks make guitars. Foil and bamboo sticks are the raw material for catching lo-custs. A group of boys captures a gray-brown rat and harnesses it to a tiny wooden cart with string.

Plastic ration bags pieced together can make a kite. When the rainy season is over, dozens of pale yellow, pink, blue and green ones with long

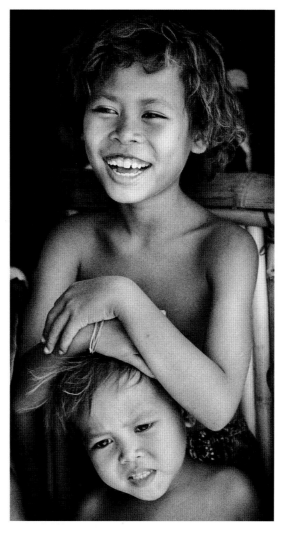

Children improvise for fun, as boys douse unsuspecting girls with water during Cambodian New Year's celebration (left); friends laugh together, and fly kites made from ration bags (below).

tails decorate the sky, flying high in the afternoon breezes.

Any object that moves, such as a small cart, can become a plaything for an inventive trio of small boys. Any ritual holiday is a welcome occasion for rowdy fun.

Children play a game called "lort anteak" with a rope made of rubber bands tied together. Most children don't go to school fulltime and have many idle hours to fill.

116

Oum Kheama, 19 years old, cries when she thinks about her two older sisters who perished in Khmer Rouge work camps. She still has bad dreams about the days of Pol Pot's regime.

NOTHING TO DO,
NO PLACE TO GO

The restless energy of adolescence is uneasily contained within the boundaries of Site 2. Thousands of teenagers are starved for entertainment. They often have limited schooling, with no jobs and many idle hours to fill. Many of the boys imitate outdated Western style and fads, wearing bellbottom pants, platform shoes and Beatles haircuts. Dressed in T-shirts and jeans and wearing sunglasses, hundreds of them hang out with their friends, listening to rock music, particularly Santana, on portable radios. ■ Virtually every teenager has suffered tragedy under the Khmer Rouge era, losing their homes and even a parent or one or more brothers and sisters. Thousands have been orphaned and now live strictly regulated lives in dormitories. Desperately lonely, they have little personal space and no privacy. Worse, the boys live in fear of being recruited into the guerrilla resistance against their will. ■ The more fortunate teenage girls whose families are relatively well-to-do, can afford to uphold the traditional mores of the Khmer, which allow little more than ritual contact between unmarried boys and girls. "Good girls" do not go out after dark in the camp, avoiding the rowdy video parlors and the colorful melodramatic Bassac Theater shows on Saturday nights. They meet boys only under the rigid social rules of Cambodian society. ■ The least fortunate become "taxi girls," prostitutes who serve many of the soldiers and even married men in camp. These girls have scant education or skills and little hope for a better future.

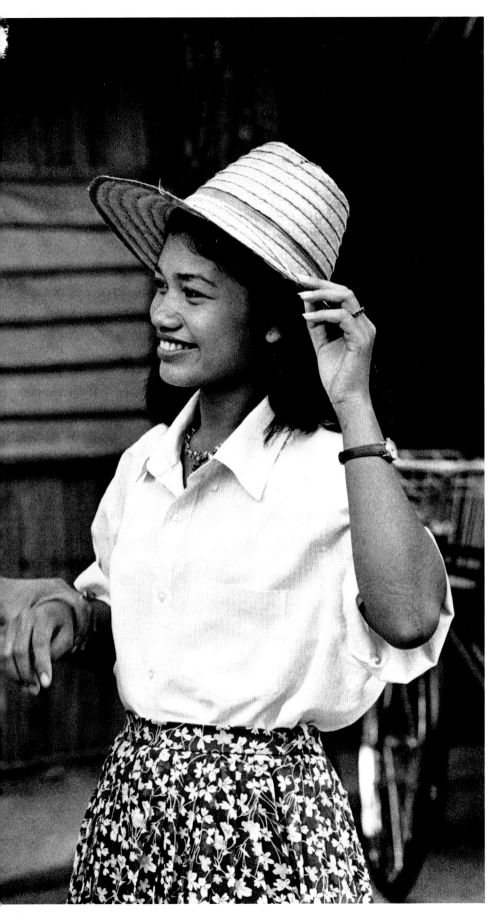

Nineteen-year-old Oum Kheama is one of the lucky teenage girls at Site 2. Her mother and father earn money as schoolteachers, and Kheama has an income of her own as a library worker. The sun hats, blouses or polo shirts and midcalf skirts set her and her friends apart from most of the other girls in camp who wear the traditional sarongs and long-sleeved white shirts. Kheama works at the Teacher Training Institute Library, takes classes in hotel management, French and English, and even belongs to a women's discussion group. After classes, she sometimes joins other students for a game of badminton.

"At home it is so boring," complains Kheama. "There are many hours with nothing to do. It is very quiet and I don't like that. I always wish there was more to do." Afraid to walk the unlit roads to see friends, she spends nights with her parents around a small fire or reading by candlelight.

Like virtually every Site 2 teenager, Kheama's life has been scarred by tragedy: Her two older sisters starved to death in a Khmer Rouge work camp. Her family fled their home in the Battambang Province to the border in 1979. The 50-day trip took them over a footpath two feet wide with land mines and dismembered bodies strewn along the way.

"It was horrible. We were afraid," Kheama remembers, "I cried many times, and my parents tried to comfort me, but what could they do? They were frightened, too."

After they have straightened the books on the shelves in the dirt-floored library, Kheama and her friends sometimes look at pictures of clothes in fashion magazines or take turns fixing each other's hair. They try different styles, and sometimes put makeup on each other. On special occasions – such as holiday celebrations or weddings – they wear lipstick, rouge and nail polish.

"When I put it on," Kheama says, "the boys say 'beautiful,' but I don't want to hear it. If they say I am beautiful, I would say thank you and keep on walking."

Kheama likes it when boys tuck in their shirts and wear sunglasses, but she has no boyfriends. "I don't want them. In Site 2, it is difficult to be married. We are not sure how long we will be living here. We could run to another place any day. It would be difficult raising a child here."

Kheama plays badminton with fellow student Horm Yean at the Teacher Training Institute (left). She and her friends take turns fixing each other's hair in different styles. They powder their faces and wear their mothers' gold Cambodian jewelry with rubies and emeralds.

Kheama's family is resented because they are better off than most people in Site 2. When she rides her bicycle in her Western-style skirt and sun hat, taxi drivers jeer. Although she and her parents still live in a dirt-floored bamboo hut like the others, Kheama has a room of her own, where she keeps her collection of ruffled blouses covered with plastic to keep out the dust.

Because of her clothes, Kheama stands out in the camp. When she rides her bicycle wearing her Western-style skirt and sun hat, she often endures the taunts of poorer people along the way.

In normal times, her parents would already have arranged a marriage for her, a tradition that is still widely practiced in Cambodia. "My parents will not force me to get married here," she says. "Back in Cambodia, yes, I would like to get married and have a family."

Although she is shy with boys, Kheama is outgoing by nature with her friends. She hopes to become a tourist agent when peace comes to Cambodia. Perhaps when the war ends, she can travel to other countries, even America.

"I have read stories about America," she says, "but I have never seen videos about what girls my age do in other countries. What do they do? What is dating? I do not know this. In Khmer culture, it is very strict. I can go to weddings and have lunch with the people, but at the parties I never dance with a boy; they will say, 'M–m–m, you are not a nice girl.'"

Occasionally, Kheama weeps as she remembers her earlier life and the loss of her two sisters in the Khmer Rouge work camps. The trek to the border camp through the continual stench of rotting corpses still torments her. "I still have very bad dreams," she says. "We are all very sad about this time. Maybe we will always have these dreams, until we can go home."

Hundreds of orphans of all ages spend an afternoon watching martial-arts films in the mess hall of the Nong Chan Orphanage.

Ly Noun (left) and more than 40 boys live in one open dormitory, each assigned a one- by three-meter space on the linoleum-covered bamboo platform. An orphan boy (right) looks into a cardboard box, which contains all of his possessions.

At the Nong Chan Orphanage, 200 boys share a bond of tragedy and isolation.

They look after each other, eat together, sleep together, and rarely go beyond the security of the compound except to attend school next door.

These boys are among 7,000 "unaccompanied minors" at Site 2. Many of the oldest were separated from their parents, brothers and sisters by Pol Pot's soldiers and forced into mobile work units. They never found their parents again. Others witnessed the murders of their family members and know they are alone.

Sixteen-year-old Ly Noun lives in a dormitory with 43 other boys. Each sleeps and stores his possessions on a one-meter by three-meter space on one of the long narrow platform beds that stretch the entire length of the long open hut. Shirts dangle from the ceiling on hangers; rubber thongs and plastic sandals litter the dirt floor beneath the platform.

While most teenagers thrive on privacy and individual expression, there is simply no opportunity for it at the orphanage.

To change clothes, a boy stands in his spot, wraps a red plaid and striped krama around his waist while he removes his shorts and replaces them with pants.

Within that space, Noun has his bedroll and a small cardboard box to hold everything he owns: textbooks, paper, pencils, a change of clothes, a small round mirror and a toothbrush.

Afternoons in the dormitory are usually quiet, with boys reading or doing their homework. Fifteen-year-old Chon Komar (below, right) and his friends play a chess – like game called "ok" with hand-carved wooden soldiers.

To be an orphan at Site 2 is to be a nonperson to the outside world. "My mother and father are dead," says Ly Noun, "and I think all my brothers and sisters are dead, but this I do not know for sure. I think about this all the time."

Before he came to the camp in 1985, Noun recalls, "I had to be a worker in the fields for other people. They made me work hard, I had no time to go to school and this made me very sad." Now he studies hard to make up for lost time.

"I am very much afraid they will make me a soldier," he says, somberly. "You do not choose. I am afraid they will come at night in a bus, and they will take me away, so I try to keep to myself."

There is little to do, so they fill the time reading, competing at "ok," a chesslike game, or playing volleyball and basketball. They also fear that they will be sent to someone who will victimize them as a slave.

Sin Setha, age 18, feels that he and his companions are the unhappiest people at Site 2. "We have nothing. I have no money to marry a wife. I will always be alone. And a family, that is what I want. So I am very sad. You know, sometimes a dream becomes a true story. So I have a dream, I would like to see the world. I dream that I go away from here."

At the age of 10, Pov Rotanna is the youngest boy in his dorm. He was left for dead with a gunshot wound to the head after Vietnamese soldiers killed his mother, father and an older brother. Not wanting to be separated from his surviving brother, Rotanna has been living at the Nong Chan Orphanage for five years.

Yoeun Phaly (left) and other taxi girls gather at a brothel in a crowded section of Site 2 near homes and food shops. A young prostitute (below) teases and insults Ly Oum, who is the oldest prostitute in the brothel at the age of 30. Oum cries all the time, the girl says, and can't get many men.

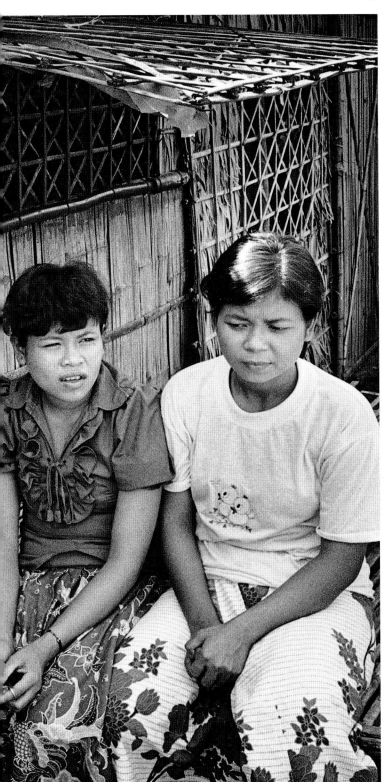

Taxi girls sit in the sunlight outside the bamboo hut that serves as a small brothel. By day, the building seems as innocent as the surrounding houses where young children play. Yoeun Phaly laughs and toys with her hair. She wears a "Miss Universe" T-shirt with a garish sarong and purple nail polish. Phaly is 17, and this is the only way she can support herself. Her husband brought her into the camp five months earlier and then deserted her.

Phaly and her friends gather for their monthly medical check-up, administered by the camp health workers. Each is given a gynecological exam, a lecture on AIDS and venereal diseases, and is handed packages of condoms.

As the sun goes down, the music starts, and drunken men carouse in the streets. Phaly and the other girls powder their faces white and don revealing sarongs to entice customers from the windows of the hut. Phaly, now one of the most popular prostitutes in the brothel, may see 10 men each night and earn several hundred Thai baht – about $8 in American money. The pimp, a former soldier with waist-length black hair and a cobra T-shirt, will take most of it.

Inside the hut, which is decorated with movie posters, a cracked mirror, and pictures of roses and classical dancers, Ly Oum weeps in anger. The younger prostitutes make fun of her.

At 30, Oum is the oldest in the house. A younger girl taunts her, saying that Oum only cries all day and no men want her. When Oum does get a man, she only gets about half the price that younger women command.

"I am a whore to feed my children!" exclaims Oum. Her husband was killed fighting in the resistance a year earlier, she says, and she has no other way to support her family. She claims that she has no family ration book and cannot get her share of food, but others believe that she sold it for money.

At night, Oum works apart from the younger girls. With her hair pulled back and her face powdered a shiny white, she leans against a bamboo pole of a soft-drink stand. She waits in the flickering light of several small candles, as she tries to lure customers. Her two sons, ages six and nine, watch from the shadows.

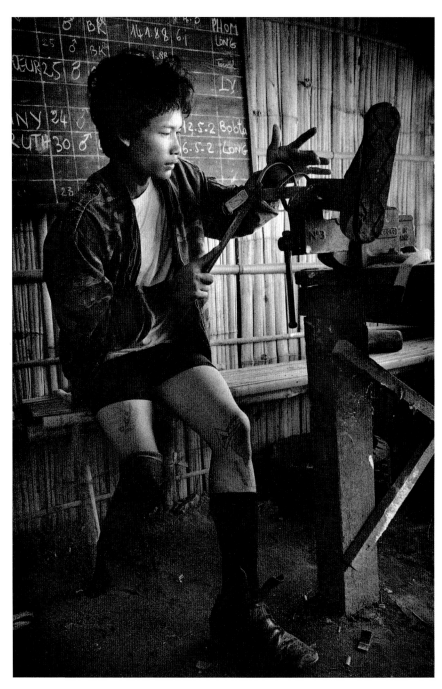

*At the Site 2 handicapped workshop, ex-soldier
Chan Peov learns to fashion his own prosthesis
out of wood, leather and old rubber tires.*

'I WANT TO SURVIVE AND MAKE IT ON MY OWN'

Chan Peov is one of nearly three thousand war-wounded at Site 2. A former guerrilla fighter, he lost his leg while he and his battalion were trying to occupy the enemy village of Sang Ha. They were only 85 Khmer People's National Liberation Front (K.P.N.L.F.) lightly armed resistance fighters against more than 300 Vietnamese with assault rifles, tanks and artillery. It was shortly after midnight, and Peov had just gunned down seven Vietnamese in a jeep, when he stepped on a land mine. ■ The bright flash and the terrible fright were the last things he could remember. When he woke up at the Khao I Dang Hospital, he knew he was finished on the battlefield. Perhaps he was lucky; he was one of 33 K.P.N.L.F. fighters to survive the battle. ■ When his wife, Noeun, heard the news from her husband's friends, she was living on the border with her family. "My heart fell from my body," she recalled. ■ He was unable to return to his family for four months. "When he came home, I could say nothing," Noeun remembers. "He felt so disappointed and hopeless, because he was now a cripple for the rest of his life. For months, he tried to have a better feeling for himself, but at first it was hard." ■ The loss of Chan Peov's leg was also a terrible loss of face. He might never again be able to support his family. "My husband saw other men with the same kind of life." Noeun said, "They had also lost their legs, so it was not just him alone. But it was hard for him to realize he would never again be a soldier. He still doesn't feel too good about this." But Noeun failed to reckon with Peov's desire and determination.

Chan Peov's 21-year-old wife, Saroun Noeun, removes his prosthesis while he holds their sleeping youngest daughter, Chan Nuch. They share the hut with Noeun's parents and their three younger children.

Peov joined the K.P.N.L.F. when he was 16 years old to be an anti-Communist resistance fighter. Today he carries the auspicious "sak" on his body, the tattoos of a seasoned soldier. The intricate patterns, he believes, protect him from harm – the knife cannot pierce his flesh.

The tattoos on his jaw will prevent his head from ever being struck. The suns on each shoulder will safeguard his torso. The trunk of an elephant runs down the length of his shin, protecting his left leg. Only part of a tiger can be seen on what remains of his right leg. Yet he still insists the magic of sak didn't fail him – it was his own failure to believe strongly enough in its power.

It was months after being wounded before Peov could regain some of his confidence. Then he became involved in the camp's handicapped workshop, where thousands of others like him learn to make their own prostheses.

"I am a man who must struggle against his own physical handicap," Peov says. "I want to survive and make it on my own."

Peov's hut has three small dirt-floored rooms – a main room with kitchen and two bedrooms partitioned by bamboo walls covered with Thai movie posters. A large tree growing through the roof of Peov's bedroom supports a shelf. On the shelf are a small mirror, a pencil, a comb, and a faded photograph of Peov dancing at a party.

Nine people live here, including Peov, his wife Noeun and two daughters, and his wife's parents with their three younger daughters. Like everyone else at Site 2, Peov washes himself with water from a jar in front of his house. He pours a bucket on his head, lathers up rapidly and tries not to waste a drop. Then he repeats the process for his daughters.

The family tries not to crowd each other in the hut, but, Peov says, "Here, you are always fighting with your neighbors over space. There are too many people in the same place. It makes people angry with each other.

"The time just goes on and on here."

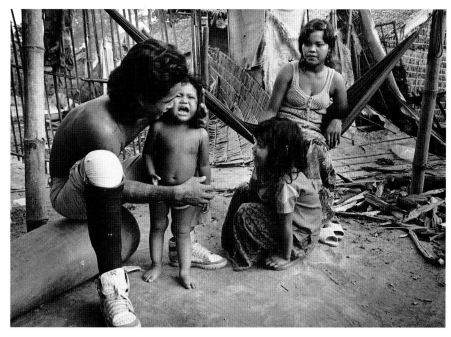

Peov picks lice out of Nak's hair. Peov and Nak (above, right) try to comfort a crying Nuch while Noeun watches. Behind them is the rickety communal outhouse of bamboo and burlap.

Peov does many of the family chores (left), making sure that the hut is clean and orderly. Careful not to waste water, Nouen bathes Nuch (far left) while Nak pours droplets of water into Nuch's mouth.

The family's day is taken up with small rituals: cooking, cleaning and washing. There are few amenities in Peov's life, and he learns to get by on what little he is given – a quick splash bath, scrubbing his teeth with his finger, and a feather to clean his ears. The tiny sample-size packet of detergent is used to wash dishes, clothes and hair.

Peov frets under the monotony, straightening piles of clothes, re-arranging the bamboo bench and table in the main room, changing clothes frequently from pants to shorts to the wraparound krama, and back to pants. He does the laundry, chops more firewood, stacks it inside the hut and then, the next day, stacks it again neatly outside.

As a young boy, Peov lived in a comfortable home with electricity and wooden floors. His father was a colonel in the Lon Nol regime. "All I can remember is being very happy," he says, but when he was 12, the Khmer Rouge took him from his parents and five brothers and sisters and placed him in a mobile youth team. He never saw them again, and later he heard all had died.

Peov is very fond of his two young daughters and delights in playing with them. He is especially close to Nak, his older daughter. They often go for long walks together, holding hands. Nak was born to his first wife, Rin Sri, while she was escaping from the village of Onha in the Battambang Province.

Peov was away fighting, and his wife had to trek through minefields and around booby traps on her way to the border. It was three months before Peov first saw his newborn child, and then while he was at the battlefield, he kept losing them as they were swept from camps during one attack after another.

What he dreaded most came true in 1983, when Rin Sri and their six-month-old daughter were killed by a Vietnamese shelling attack on the camp where they were living. Peov still grieves for them and his three-year-old daughter who later died from disease and malnutrition.

Since losing his leg, he has fathered a fourth daughter, Nuch, by his second wife, Saroun Noeun. "It is my worst fear that the shelling will happen again," Peov says.

Peov and other handicapped soldiers peer through a bamboo screen to watch their children in school. In class, Nak excitedly holds up her chalkboard with Khmer characters (right). Her education already surpasses Peov's.

As much as she likes school, Nak prefers to stay home with her father. "I love my father," she says. "I wish he could read me stories, folk stories. Sometimes he tells me stories without reading."

Peov has encouraged Nak to attend school, where she takes courses in reading, writing and arithmetic. Her favorite subject is Khmer literature, because she likes to write and tell stories in school. Even though she is only in the first grade, her education has already surpassed her father's schooling, and Peov is proud of her.

At school, recess comes as a welcome break for Nak. She runs outside with her friends, ignoring the teacher's warning to slow down. Outside, they play games, similar to paper, rock and scissors, hopscotch and one where they spin each other around in a whip and fall down laughing.

Nak likes to play house. "I pretend to be the sister or daughter of a housewife and the other children pretend to be brothers and sisters," she says. "We pretend to cook rice, vegetables and soup."

The truth is that most of the time Nak is hungry, and she fantasizes about eating rice or drinking Coca Cola.

And at night, "I just stay home and sometimes I do homework. I just go to sleep. When I hear the shelling, the fighting in the distance, it scares me."

Nak plays with the axe while her mother makes lunch. Noeun adds wood to the kitchen fire (right) to boil some rice. Nak (below) eats a piece of bread while she waits her turn to eat with her five-year-old aunt. Peov's father-in-law, who is visiting from the battlefield, is third from left.

Nak helps with the housework, sweeping the hard-packed dirt floor of the hut twice a day. She cares for her baby sister, Nuch. Nak often assists her mother with the cooking and shopping. The family is very poor, and they have to borrow eating utensils, glasses and plates if several members are home at mealtime. Usually the children eat after the adults finish. The plates are rinsed off and used again.

Noeun, a quiet, sullen woman, has been borrowing money from a neighbor to buy fish from a Thai trader. Then she sells the fish at the market behind their home. In this way, she hopes to make enough money to pay her loan and get a little extra to keep.

"I wish life here would improve,

and I always wish we had better food to eat," she says, rearranging a few dented pots in the small kitchen.

The smoke lingers as Noeun adds wood to the stone stove in order to boil rice for lunch. Rays of light filter through a hole in the palm-thatched roof of the kitchen.

Sitting on the floor of the hut, Nak pounds the dirt with an axe and chases away a scrawny chicken that has wandered inside.

Peov worries about Nak. "It may be years before Nak ever sees a village or a farm," he says, "and there is only so much that I can tell her." More important, Peov laments, "She doesn't have enough food for her body. She has so little food, she lost her appetite."

Nak sweeps the dirt floor of the hut twice a day. She plays with a yellow-haired doll that was donated to relief agency. Toys are in short supply and often have to be passed around from family to family. Peov often worries about their future. Nak has no idea of what her homeland is like (next pages).

Peov and Nak often take walks through the market, but he cannot afford to bring home clothes, fancy spices and radios that some of the more priviledged can buy. However, a pink-skinned doll with yellow hair and blue eyes has found its way to Nak's home. She and her young aunt caress, bathe, and play house with the doll. Then one day it is time for the doll to be passed along to other girls in the neighborhood.

While Nak is small for her age due to her poor diet, she is, nevertheless, playful and energetic. Her schooling is limited, and she has no idea of what her future holds. When Nak grows up, she dreams of working in a factory. Not any factory, but a textile factory, because, she says, "I want to wear beautiful clothes."

In addition to walking with her father, Nak likes the Sunday theater shows, especially the fairy-tale pageants. "I enjoy the story about the queen and king," she says with a giggle. "The king has power to control; he can hit and punish. But the queen has beautiful clothes. She can speak the sweet words to the people."

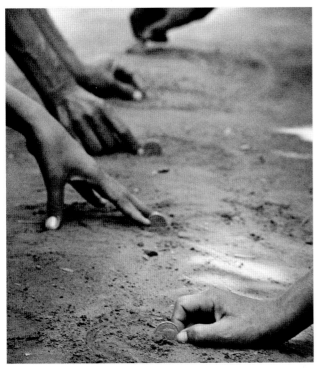

With the money gained from selling his family's food rations, Peov quickly buys into a neighborhood gambling game called "khrorb kampleung." He wins by bowling down coins standing on edge in the dirt. He gets to keep the coins he knocks over with the stone ball. If he is lucky, he will win enough to buy back some rice and perhaps some vegetables. If there is still some money left, he will buy a sweet for Nak.

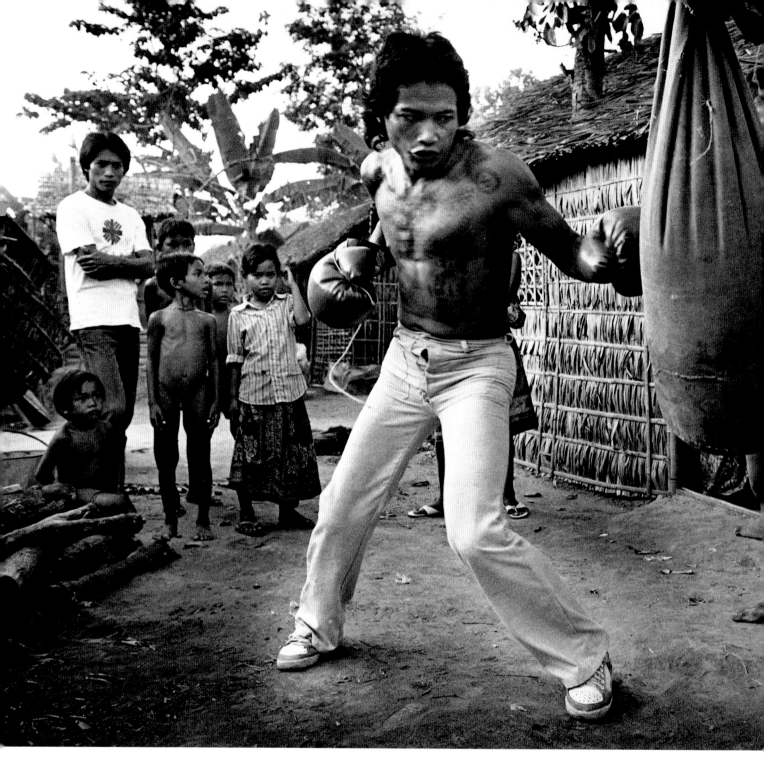

Despite the loss of his leg, Peov has remained remarkably fit. To stay in shape and earn extra money, he has begun to teach boxing. He began to study boxing in 1982, and he is very competitive.

"I don't really want to beat anyone up," he says, smiling, "But I get kind of shy when I'm beaten up by somebody else in front of a lot of people. So, rather than losing, I would rather win."

Naturally athletic, Peov competed not only in boxing, but in the javelin throw, the shot put, volleyball and weight-lifting during a competition sponsored by the handicapped workshop in which he crafted his own prosthesis.

He usually gives his lessons in the late afternoon as the oppressive heat begins to ease, and his sessions almost always draw a crowd. Even wearing his prosthetic leg, Peov can

Peov's boxing lessons, which are taught in late afternoon as the heat of the day wanes, usually draw a crowd (left). Peov's childhood friend, Nhean Bunyoeung (below), urged him to return to school. The two joined the resistance together and fought side by side until Bunyoeung lost his leg in 1983. Now they are neighbors again at Site 2.

deliver some swift kicks to the punching bag as he teaches kick-boxing to a neighbor in front of his hut.

Peov is moody, and sometimes he explodes in anger. In 1988, he became enraged when he suspected a neighbor of stealing something from a friend. He viciously attacked the man with an axe, but his wife pulled him away so that he only cut through the neighbor's hand.

Claiming that his honor was tar-nished, the man told his relatives to retaliate. The incident sparked months of recriminations. Peov had to go into hiding for a while, and Nak stayed out of school.

Noeun, who was injured in the fracas, was afraid to stay in the hospital, fearing revenge. Eventually, section leaders held a special meeting to negotiate a truce. Peov and his adversary had to sign the agreement with thumb prints.

Peov is puzzled (left) as he starts his education from scratch. On the first day of school (below), he watches the teacher write the Khmer alphabet on the chalkboard. Then the teacher takes Peov's hand to form the letters. The entire class is made up of former soldiers, many of them amputees like Peov, who have never had the opportunity for a formal education.

Peov had less than a year of education at Buddhist temple school before Pol Pot's soldiers took him away to a mobile labor camp. Finally, after a year of cajoling and encouragement by some friends, he agreed to attend classes at the technical school. However, he would have to learn to read and write basic Khmer first.

He showed up at class with a haircut, pencil and paper, wearing a borrowed wrist watch to make sure he wasn't late. The entire class was made up of soldiers with missing limbs or suffering from other war wounds.

The teacher held Peov's hand to help him form letters of the Khmer alphabet on his blackboard. At recess, the soldiers gathered around the bamboo desks to smoke and talk.

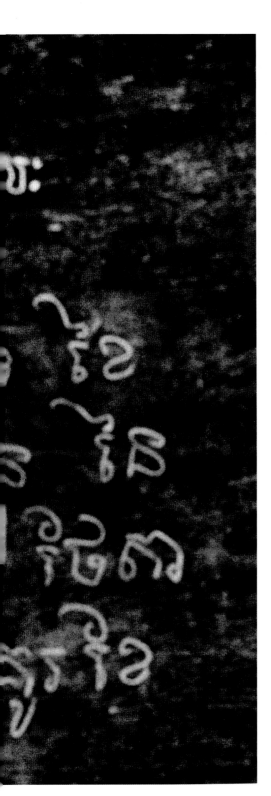

Peov made rapid progress in his language class and moved toward learning simple addition. Until he learned to read and write Khmer sufficiently, he would not be allowed to take more advanced classes in radio and watch repair, typing, etching, sculpture, and automotive repairs.

Peov would like to be a rice farmer once he returns to Cambodia, but his injury probably would prevent it, so he will have to find a different way to support his family.

Before his afternoon class begins, he checks the automotive-repair class next door. In a space littered with the various remains of motorcycles, trucks and automobiles, Peov watches a student work on an old truck engine.

After a few weeks, Peov has enough confidence to take his turn leading the class with their lesson. Before his afternoon class begins, he drops in on the automotive-repair class next door.

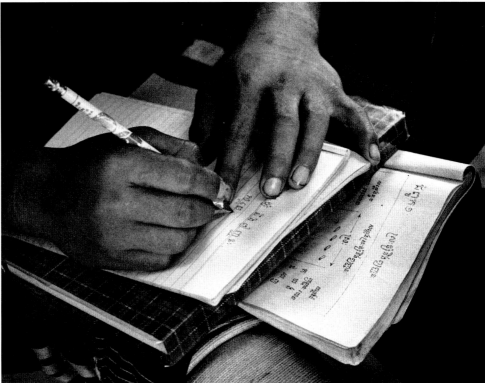

Nak waits for Peov to get home to remove a splinter from her finger (left, above). After he arrives, she helps him with his homework, since she is beyond his rudimentary level.

Now that he goes to his own classes, Peov has less time for Nak, his favorite daughter. One day she waits, watching out the window for hours, until he can get home to remove a splinter from her finger. Nak cherishes her time alone with her father.

Since Nak is more advanced in school than her father, she can help him with his homework. He is determined now to make something of his life, even though he has lost his leg. His boyhood friend, Nhean

Bunyoeung, had been encouraging Peov to take classes at the handicapped center for some time. Bunyoeung joined the K.P.N.L.F. with Peov and also lost his leg to a land mine in 1983.

Another long-time friend told Chan Peov that he would have nothing further to do with him until Peov started to try to improve his life. He told Peov that he should think about his future and what he needs to do to support his family when they are allowed to go home to Cambodia.

Even though one international conference after another fails to bring peace to Cambodia, Peov is still optimistic. Yet it is hard for him to keep up his spirits.

Some days he is in a melancholy mood when Nak comes home from school. One afternoon, he answers his daughter's light-hearted rhymes with sad Cambodian songs.

He closes his eyes, furrows his brow and sings in a sure, sweet tenor voice. The songs are about his friends lost on the battlefield, missing his homeland and the love for his dead wife.

All conversation stops around him, and neighbors peek in through the bamboo lattice to see what is going on.

With sweat rolling down his forehead and tatooed chest, Peov shakes himself out of his mood and sings Nak's rhyme about a big-eyed owl and croaking frogs and they all laugh.

"One day I thought I would just walk around the camp and have a good time," Peov recalls wistfully.

"By the time I got to the reservoir, I thought this was a day that we were all going to be happy. I went home and said this to my family, and so we all started out on a little walk.

"We were all going to be happy. And then, when we got as far as the reservoir, somebody threw a hand grenade at someone else, and there was a big explosion.

"We all ran home."

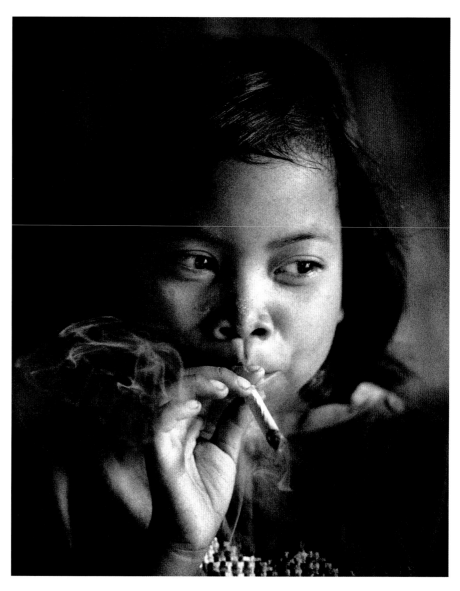

To the amusement of the adults, Nak sneaks a cigarette from Peov's pocket and smokes it. Peov (right) holds his sleeping two-year-old daughter, Nuch.

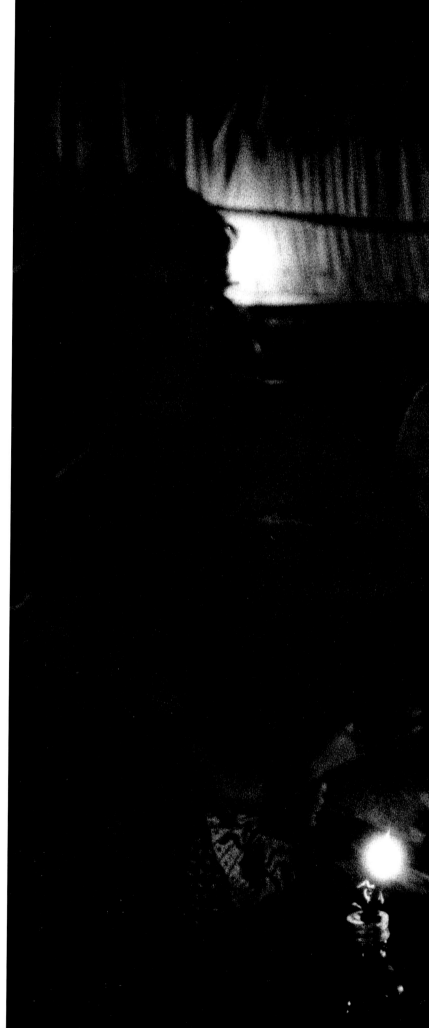

At night, Peov and his family sit in their hut, which is only lighted by candles. Most residents are afraid of encountering bandits or drunken soldiers at night, so they stay close to home.

At night, Chan Peov and his family sit in the darkness of their hut, which is lit only by thin orange candles. The sound of husbands and wives fighting, watchdogs growling, and mournful music is a counterpoint to the distant artillery shelling.

The fear of a sudden artillery attack prompts the family to pack their essential belongings every night. These include clothes, blankets, a mosquito net, a cooking pot and dishes, some rice, a water container and a bamboo stick to carry the bags.

"Things are more dangerous at night," Peov says. "The night brings darkness and darkness brings mystery. You don't know what's going to come because you can't see it. The enemy could attack. There could be shelling.

"Our children might run away and people couldn't find them in the darkness."

"I accept the fact that there is no electricity here and I also accept the fact that I might have to sleep in the rain or even sleep in a mud puddle, and I do what I have to do to survive."

Still, Peov is optimistic. "It's very difficult for my family to live here," he says, "but still, I have great hope in my heart."

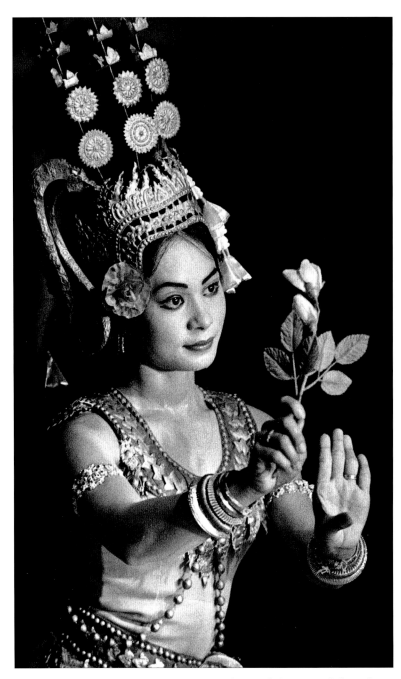

Sewn into her "Apsara" costume, a classical dancer exhibits the grace and beauty of Cambodian dance, reminiscent of the bas-relief figures at Angkor Wat. The ravages of the Pol Pot era left only a few people who remember how to carry on the tradition.

THE UPHILL STRUGGLE
TO KEEP BEAUTY ALIVE

On a bamboo stage covered with linoleum, a troupe of dancers performs. The spotlight is powered by a generator that thumps behind the music. The costumes are decorated with rhinestones and glass and pieced together with scrounged materials. But the dance is classical Khmer, known the world over for its grace, beauty and intricate steps. It dates back a thousand years to India and Java and dramatizes scenes from Hindu myths and Buddhist tales. ■ Once performed before royal courts, the Khmer ballet featured dancers in ornate costumes and headdresses adorned with gold and silver, pearls and jewels, similar to those worn by "Apsaras" in the bas-reliefs of the ancient temples of Angkor. Today, the Cambodians at the Site 2 border camp cling to a remnant of that tradition. ■ The Khmer traditions in general have begun to erode away in the grinding squalor of the camp, and the once-rich and vibrant Cambodian culture is gradually surrendering to "camp culture." The markets run on Thai currency. The checkered krama, once used as a scarf, a sling for a baby or to carry food from the market, was an integral part of Cambodian tradition. Now, few residents wear the krama, some fearing it is too closely associated with the Khmer Rouge. Thai words have crept into the language, diluting the subtle, traditional levels of meaning once understood by native Cambodians. ■ Despite the daunting odds, the people at Site 2 hold on to their old customs. Keo Daravuth (whose real name is withheld for security reasons), a Cambodian relief worker, points out that Angkor Wat, the capital of ancient Khmer civilization, was lost to the jungle for 500 years, and yet it survives. "I think the Khmer culture will survive. We have a very strong identity."

Srei Mom was a 20-year-old principal dancer with the legendary Royal Ballet of Cambodia. She toured the United States, Canada and Japan. She recalls the brilliant lights, the dazzling chandelier and the deafening applause at the Kennedy Center in Washington, D.C.

Under Pol Pot, many of her fellow dancers were killed. Others died from starvation and lack of medicine. Srei Mom had to hide her soft, manicured hands from the Khmer Rouge soldiers. There was no more dancing, only hard physical labor.

Today, Mom has returned to the stage as president of technique at Nong Chan Fine Arts Center in Site 2. Since 1981, she has been teaching classical dance on a stage elevated on bamboo stumps and covered by linoleum.

Srei Mom warns the children who study under her that they have a great responsibility. "Many of these children grew up in camp. They had no dance before," she says. "I want to keep Khmer culture alive."

172

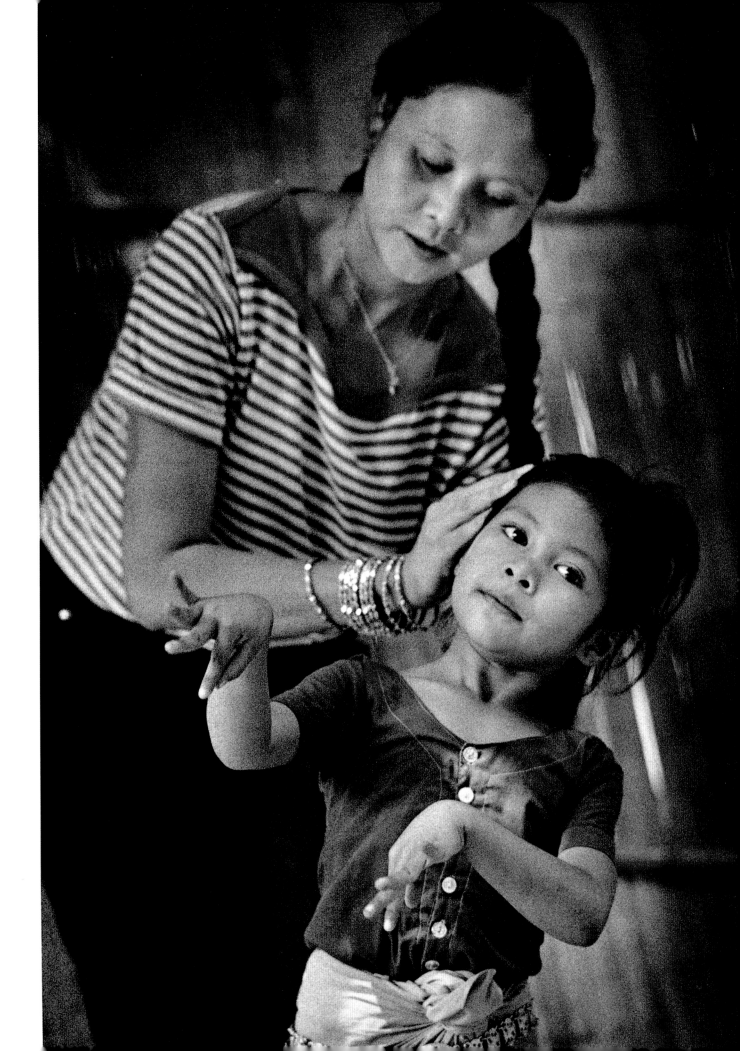

Srei Mom teaches a young student the body positions and hand movements of Cambodian classical dance (left). Youngsters watch a musician play from memory some of the familiar songs to accompany the young dancers.

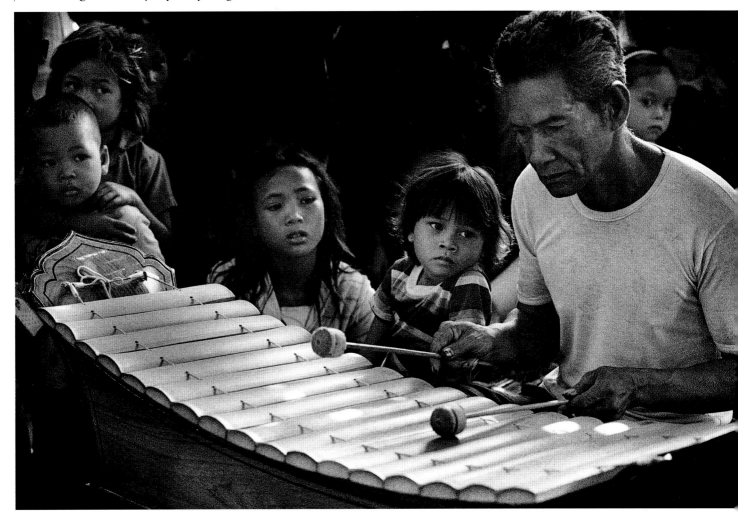

Srei Mom starts teaching children when they are six years old. Even before that, three- and four-year-olds jostle around the primitive stage, pressing their fingers back trying to imitate the graceful classical hand movements.

But for Mom's pupils it is all business, and a careless tilt of the head or misplaced toe is swiftly punished by a swat and a scolding.

A performer who has appeared on some of the great stages of the world, Srei Mom is one of the few women in camp to wear Western-style clothes – usually a turquoise and white-striped top over black slacks.

Five days a week, under Mom's critical eye and ear, the musicians play the familiar tunes on the traditional Khmer instruments–"korngthom" gongs, "chop choeng" finger cymbals, "tro ou" and "tro sor" two-stringed violins, long drums, wind instruments made of bamboo and wood, and "raneat thung," the bamboo xylophone.

Cambodian music has no notation system of its own, and so songs are passed on by ear from one generation to the next.

One of Srei Mom's students claps the shells together, practicing the "coconut dance" (below). The folk dance, along with the "white dove peace dance," are among the most popular dances in Cambodia.

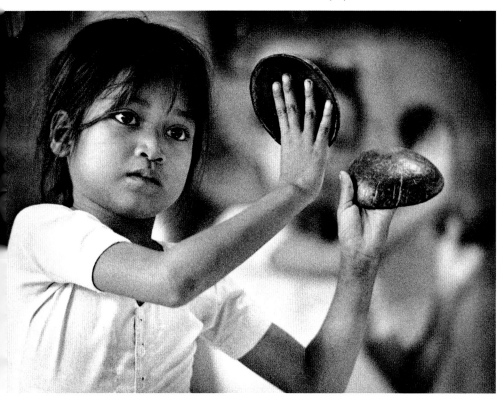

The young dancers, dressed in fitted shirts with colorful "sampot" fastened at the waist with silver-tone chain belts, wear costumes that they have made from colorful fabrics donated to Srei Mom's class.

A young dancer claps coconut shell halves together, practicing the "coconut dance." This folk dance and "Apsara" classical dances were among the most popular dances in Cambodia. The class also performs the "crocodile" and "krai thorng" dramatic dances.

Voan Savay, a fellow dancer in Srei Mom's troupe, remembers when they were greeted backstage at the Kennedy Center by then-President Richard M. Nixon.

It was an ironic moment: The man whose 1970 bombing and invasion of Cambodia is thought by some to have paved the way for the rise of the Khmer Rouge, told Savay how much he enjoyed the performance.

"He said that he hoped there would be peace in our country," she recalls. "He said the ballet was beautiful, and that when there was peace, more people would be able to see it."

Thousands crowd into the hot, dusty field each Sunday afternoon to see the same plays they saw last week and the week before that.

Vendors sell soft drinks and snacks. The crowd laughs, oohs and aahs in unison as youngsters learn the folk tales passed down from generation to generation.

The brightly costumed Bassac performers are carrying on one of Cambodia's rich theatrical traditions. These groups originated in Bassac Province in lower Cambodia, an area that is now part of Vietnam. The actors, with their elaborate headdresses and painted faces, swoon, dance and battle in traditional dramas of love, jealousy and bravery. Modern-day political plays tell the story of Cambodia's invasion and occupation by Vietnamese troops, with actors dressed in camouflage and carrying painted wooden guns.

Music and dialogue is amplified through loudspeakers powered by a generator. Children press close to the makeshift stage to get a better look at the performers. Too close can bring a slap with a bamboo switch by a Khmer policeman. Lucky kids get to work on a team that opens and closes the patched blue curtain on cue from the backstage director.

178

A battle on stage at the popular Sunday La Khon Bassac theater in Site 2 draws the rapt attention of adults as well as children, who crowd around the stage to get a close look.

The New Year's tradition, adapted from the Thais, of patting powder on the faces of unsuspecting people allows a boy to take liberties with a girl that are forbidden the rest of the year.

Single Cambodian women and men do not socialize together under traditional rules. One exception is the New Year's celebration, three days of parties, rituals and games in mid-April, traditionally after rice harvest and during school vacation.

Students, such as those from Dangrek High School, prepare a big party. They send invitations to special guests, make streamers and decorations, prepare a feast and build a dance arena with a stage.

Many boys wear sunglasses and their coolest clothes. The girls dress up in ruffled blouses, artificial flowers in their hair and faces powdered. Pink is the most popular color for girls.

The dance floor soon fills with young men in their late teens and early twenties, dancing to American rock 'n roll music with Khmer lyrics. Girls stand shyly around the outside of the circle, watching the boys dance. As the music turns to a traditional Cambodian tune, the boys shift to a graceful swaying step with swirling hands as they circle in the "ram vong."

Young men dance and court the women by showing off in a game of "bos chhoung." They make bird calls, sing about the women, the way they smile and the way they walk. The women wear their finest clothes but are coy in response to the flirtatious overtures.

The center of the New Year's festivities is the Buddhist wat, or temple. It is a time to pray and to plan for a better life in the year to come, but most seem to be there for the fun.

A fortune teller with long dreadlocks is on hand. "Yeay chi," pious elderly women, wash the temple's brass Buddha statue. Concession stands sell candy and dried fruit on sticks. The courtship games begin.

The young people take to it with enthusiasm, with the boys showing off and flirting outrageously and the girls coy and giggly. Underneath the frivolity is a more serious search for a possible future husband or wife.

In "bos chhoung," men and women face each other about 10 meters apart. A young man throws a scarf rolled into a ball at a girl who strikes his fancy. If she misses catching it, she must, as a penalty, sing and dance to please him. He must do the same if he misses it when she throws it back.

A cheerful tradition borrowed from Thailand has been incorporated into the Khmer New Year's celebration. Originally, the "sangkran" custom was to bathe parents at the new year to show gratitude and to purify them symbolically.

Now young people throw water or slap powder on anyone they can catch. The boys take full advantage of the game to tease the girls.

Young people are often married by prearrangement. Ouch Ravy, age 18, and San Sopheap, age 19, willingly follow the wishes of their parents. On the first day of the ceremony, the bride dresses in the golden brocade "kben," a formal attire.

She wears gold-strapped platform highheels over stockings with a run in them and ornate anklets and several bracelets. Hairpieces, rhinestone earrings and necklace complete the rented ensemble.

The groom, his face powdered white and his cheeks and lips red, walks nervously next to his mother under an umbrella. His rented wedding outfit includes a blue jacket (several sizes too small), a yellow-orange brocade "kben," finished with bright blue and yellow running shoes and high red and white socks.

A family procession follows, bringing gifts of food and drink to the bride's home.

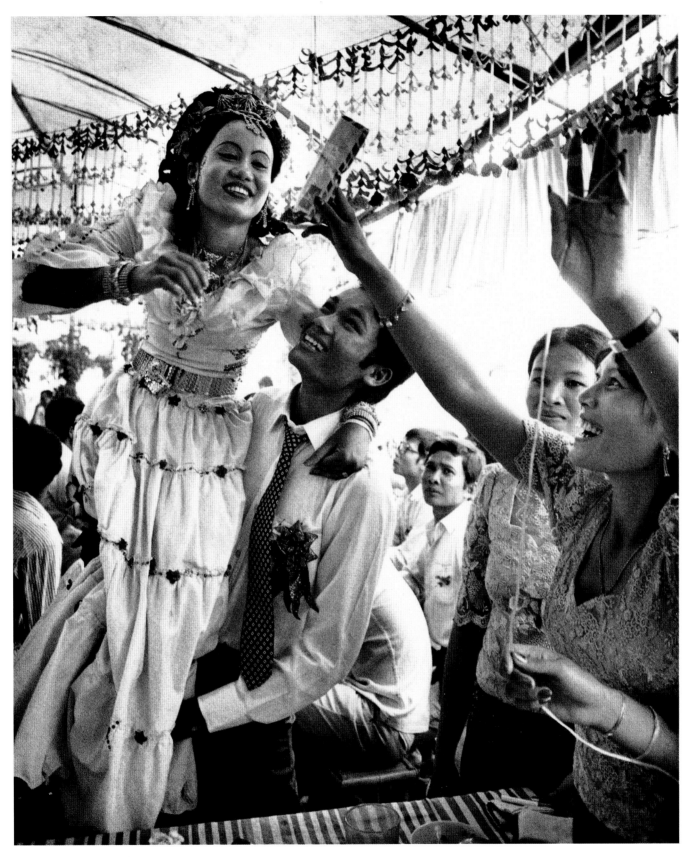

San Sopheap and his bride Ouch Ravy are married in a solemn ceremony. A relative (upper, left) speaks into microphone praising the couple. A parade of the groom's family brings gifts of food to bride's home (left). Ravy reaches for money gifts (above) at their reception.

For each part of the ceremony, the couple changes clothes. The first day, they sit quietly at a table covered with artificial lavender flowers, fruit, three candles, and the sword used to chase evil spirits from the new family.

Relatives and friends take turns at a microphone to talk about the character of the bride and groom and ask permission for the union.

A priest gives the couple a symbolic haircut to cleanse and purify the body and spirit. The locks of hair are mixed in a bowl with some perfume to signify the sharing of the bride and groom.

Most wedding gifts are money, to help cover the cost of the feast, which can be considerable. A lavish wedding such as this can take years of savings. Sometimes, parents even mortgage ration books to pay the debts incurred.

As part of the fun, in order to receive the money gifts, the bride and groom must follow the prankish directions of their benefactor.

The groom's friends tease the couple, making them earn their money envelopes by having the groom try to light and smoke a cigarette that passes through his bride's lips. The object is to get the bride and groom closer.

Ravy and Sopheap, the bride and groom, are full of hope. "I want to be an engineer," Sopheap says. "We will have many children. I am so very happy," Ravy adds.

To bring the bride and groom close together, a guest improvises a game in which both eat a piece of banana at the same time. They do not kiss, but break away laughing.

More than 100 guests eat an extravagant catered meal and consume large quantities of whiskey. A live band plays the sad Cambodian wedding standard lamenting the wife having to leave her family. A woman singer entertains the guests at each table, cabaret-style.

It is important to have as many people as possible at the wedding or to have them hear about it over the loudspeakers. The more people aware of the wedding, the stronger the commitment and the more respectable the union is considered.

At the end, the newlyweds receive "ptem," the tying of knots in a white-string bracelet as blessings from their elders.

Despite the happiness of the celebration, the wedding ends on a sour note. A Thai guard from the Displaced Person's Protection Unit intrudes upon the reception, gets drunk and demands more whiskey. He takes offense at what he believes to be an insult and angrily slaps a Khmer man attending the party.

Suddenly, the violence has shattered the joyful mood of the event. The guests stand silent. The wedding party is over.

Several days later, the guard apologizes to the head of the camp's Khmer Buddhist Association and is disciplined by camp authorities. But the lesson is there for all. No matter how hard they try to lead a normal life at Site 2, the threat of violence will always be present.

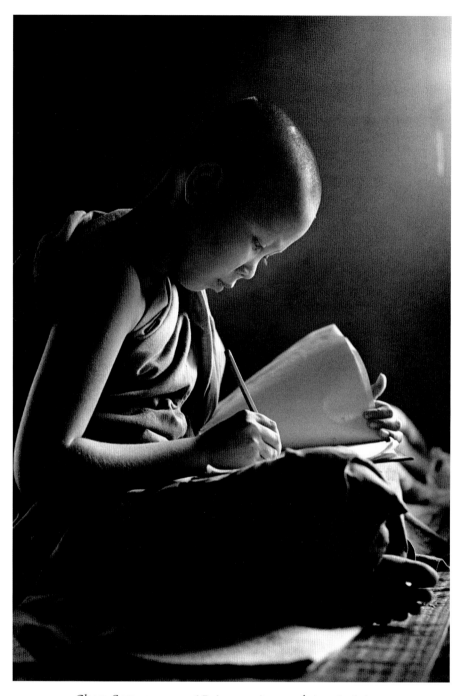

Chom Samnang, age 15, is a novice monk in a training program to revitalize the Buddhist religion following Pol Pot's cruel efforts to eliminate it from Cambodian society.

BRAVE REBUILDING FOR A FUTURE CAMBODIA

The border Khmer have suffered greatly, but their confidence in the possibility of a better world seems to be limitless. Great progress had been made in teaching Khmer to read during the Sihanouk years, but the Khmer Rouge genocide drove education back to the stone age. Pol Pot's regime murdered thousands of teachers, students in higher grades and even those who merely wore glasses. Textbooks were burned or dumped into the river. The entire school system was judged to be "Western contamination" and destroyed. ■ The professional classes were either killed or went underground, changed their names and pretended to be farm laborers. ■ When hundreds of thousands of Khmer flooded to the Thai border in 1979 and early 1980s, their initial thoughts were for survival, then a quick return home or resettlement in a third country. But as no immediate solution was reached and Site 2 became a permanent home, concern grew for the thousands of young children, teenagers and young adults whose schooling had been interrupted or never had a chance to begin. And as time goes by, new babies are born whose only connection with the outside world as they grow up will be through education. ■ Today the border Khmer look beyond mere survival to perpetuating the traditional knowledge and culture of their people through new generations. "You cannot leave this problem alone, because it is the future of our country," says Tet Bo, a Site 2 resident who helps coordinate teacher-training programs. "Maybe it is the most important thing we do here, to teach our people and fill their minds."

Students from a Site 2 elementary school flock into the schoolyard after their classes have ended. Many of them attend classes sporadically, since their parents, most of whom are uneducated, do not push their children to go to school.

In Site 2's elementary schools, students complete a six-year curriculum that may give them only basic reading and writing skills. With most of the teachers marginally literate themselves, the instruction is rough and sometimes superficial.

Some students may only be able to scrawl their names on a piece of paper after years of instruction. Even this is considered progress compared to the illiteracy of the Khmer Rouge movement.

Today there are 45 elementary schoolyards scattered throughout the camp. School is divided into morning and afternoon sessions, five days a week, with rice distribution day and Sundays off.

At first, under the auspices of U.N.B.R.O., Site 2 only offered elementary-level schooling to the very young. Pressure began building to teach adolescents and young adults. The Thai government, as part of its "humane-deterrence" policy, resisted but later relented, allowing high-school courses.

Although Western relief groups assist the teachers, the actual teaching is done by Khmer instructors to insure that the subjects will be practical and relevant to a time when the people eventually return to Cambodia.

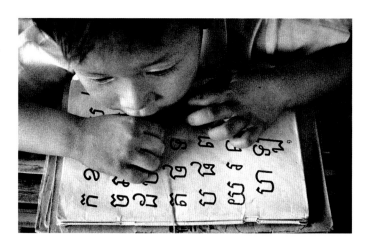

A boy has difficulty with the Khmer alphabet (right). In the classroom, children stand up and sing an old Cambodian rhyme in unison (below). Chan Nak (right-hand page) works out an arithmetic problem on the dirt floor of the school.

Sitting on mats on the dirt floors of the classroom, Chan Nak and other girls check the math equations written on the board. At the other side, boys look at one boy's answers. These nine- and ten-year-olds are in their second year of school at Site 2.

Boys sail paper airplanes while the teacher grades papers. One boy looks outside, eager for recess.

The teaching in these schools relies heavily on memorization and repetition as the children stand in neat rows and recite their numbers one to one hundred, chanting in unison.

While many of the children bring notebooks and pencils, some have only pieces of cardboard from food-ration boxes as chalkboards.

Attendance is often sporadic since many parents, themselves uneducated, do not value education and do not always insist that their children attend school faithfully.

196

Teens squeeze to the front of a bulletin board outside the Dangrek High School office to find their names on lists of students qualified to take high-school entrance exams. Din Dia, age 13, sneaks a glance at Chin Yat's test answers.

Tension is in the air as students begin their entrance exams that will last several hours. Sitting at rickety bamboo tables, they are drilled in geography, history and basic science. Most of the 20 students are boys.

This high-school-entrance exam is a crucial turning point for most Cambodian students at Site 2. Failure to get a passing grade means the end of formal education, with classes in typing, radio repair, machine shop and other practical subjects as the only other paths to advancement.

For young men, the stakes are especially high. If they do not do well in school and continue their education at a higher level, there is a strong chance they may be called to fight in the K.P.N.L.F. resistance army.

"How to destroy the fly that causes dengue fever?" is one question on the exam. "Who in our legends was the king [of Cambodia] who had no fear?" Finally, the students are asked to draw a map of Cambodia, complete with lakes, rivers and major cities.

As the exam drags on, some students have more difficulty than others. Cheath Sovanna, age 15, is the last pupil in her class to finish. The test, she says, "is very hard, but I think I did well."

Sovanna says her family is proud of her, because she would be the first in her family to attend high school.

198

Widely respected for his integrity, Dangrek High School Principal Lak Chin Savath is one of the few camp residents who has been permitted to attend courses in the United States.

Savath insists that education will be the salvation of Site 2. "These classes are the best future for all of the Cambodian people. Life in the camp can be sad, but we must prepare. We must learn. We know that if there is any good life for us after this camp, it will come through schooling."

By the sixth grade, boys outnumber girls 20 to one because of a high dropout rate. Many parents are reluctant to have their daughters learn to read and write, fearing they will write letters to boys.

In Cambodia, most girls were not educated beyond the most basic level. They simply married earlier than the boys. Also, the schools at the Buddhist temples only accepted boys. Parents at Site 2 reinforce the belief that girls belong at home, but Lak Chin Savath says he is trying – with limited success – to overcome these restrictions.

For those students who have reached the highest levels, there is the rough equivalent of graduate education, training in law, public policy, economics and government at Site 2. Those who master these advanced subjects may well become leaders in a new Cambodia.

Sadly, only a handful of Khmer students are thought to really excel in those fields, and Western teachers doubt that many of them would qualify for scholarships in Europe and the United States.

201

Sometimes, preparing for the future means conserving and reestablishing the past. Chom Samnang, age 15, is a link in that process. His day begins at 4 a.m., when he joins other monks in the "vihear," or temple, in the center of the Rithisen wat. Facing the large brass Buddha on the altar, flanked by artificial flowers, burning incense and two candles – for compassion and wisdom – they bow and begin their morning prayers.

As the sun rises, they chant the Ten Precepts of Buddhism in the ancient Pali language, derived from Sanskrit.

Theravada Buddhism, practiced by more than 80 percent of the population of Cambodia, was the state religion mandated by the national Constitution. Buddhism was the spiritual rock and primary provider of the value system and center of the community.

The Pol Pot years all but destroyed Buddhism. In April 1975, there were 4,000 temples and monasteries and 66,000 monks. The Khmer Rouge took

over and killed more than 25,000 monks on the spot, including chief monk Huot Tat. Most of the rest were disrobed. Pol Pot soldiers destroyed 1,968 temples. Buddhist texts were burned. Within months, there were no monks left in Cambodia.

Today, the Rithisen wat in the south section of the camp has 150 monks and is the largest Khmer Buddhist temple in the world, according to its leader, Venerable Heng Monichenda. It is the site of festivals, entertainments and a place where Khmer can seek counseling. There newborn children are named. Later boys will be taught to read and write in the temple school.

In trying to increase its numbers and spiritual influence, the temple encourages boys and young men to follow the Buddhist tradition of ordaining for at least three months at the wat.

There is hope that many of the 1,000 novices now in training will stay on to become "phikkhu" monks and help rebuild Buddhism.

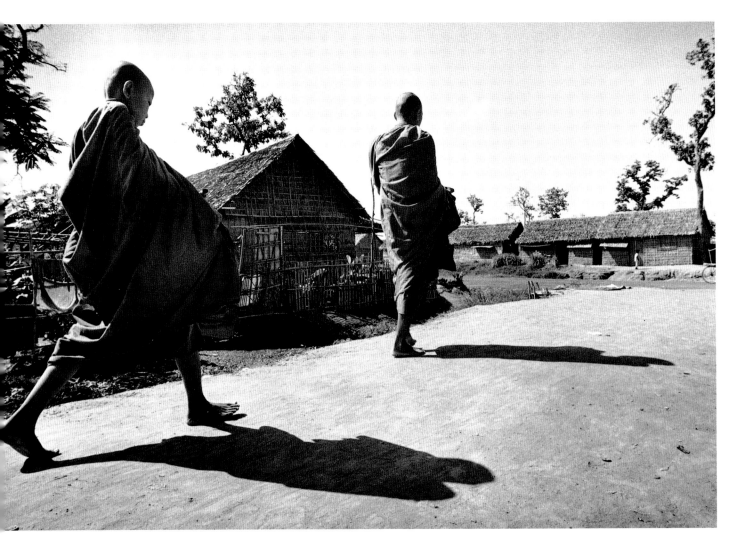

*Samnang (above)
strides to keep up with
a fellow novice on a
walk to collect alms
from camp residents.
The novices, or
"samanera," are lined
up (right) to receive a
handout of rice during
a New Year's
celebration. They eat
the food (right-hand
page) they collected on
the alms walk.*

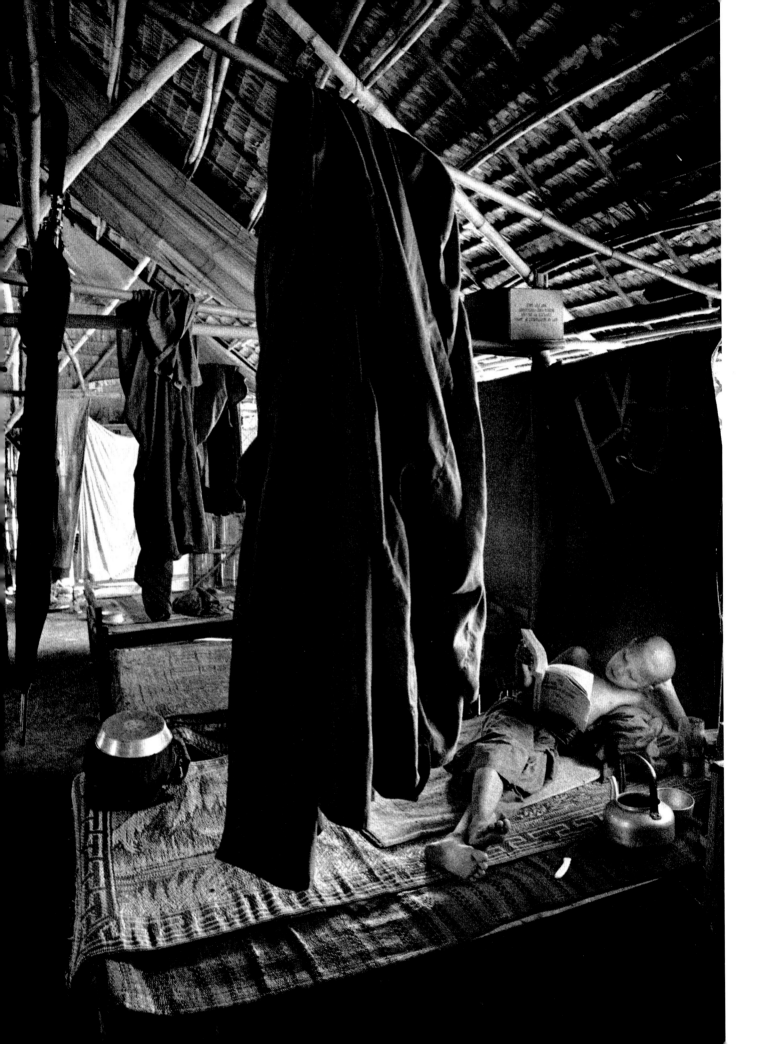

Samnang reads alone in the room he shares with other samaneras (left). He has only eight possessions: a sarong; an over-robe; a shoulder robe; a waist belt; an alms bowl; a needle to sew robes; a razor to shave his head, eyebrows and beard; and a water strainer to remove living things – mosquitoes and larvae – he might swallow accidentally. After lessons, he relaxes with other novices outside their classroom.

Chom Samnang came to the border camps in 1979 with his soldier father, mother and two brothers. After his father died in 1987, he came to the Buddhist temple to grieve and pay his respects by ordaining as a novice monk, a "samanera."

Following the ancient practice, he vowed to learn discipline and self-control, along with the three key qualities of Buddha: wisdom, compassion and purity. To dedicate one's life to self-improvement is considered the highest respect one can pay to a parent who has died. Although he originally planned to ordain for just a short time, he had decided to continue his studies and become a "phikkhu" monk at 21.

After morning prayers, Samnang and other monks take their iron alms bowls and walk silently in their flowing saffron-colored robes through the camp to receive food. The faithful wait in front of their huts for the monks to come by, bow respectfully, then place rice or other food in the bowls as a means of increasing their own merit. Unfortunately, because food is rationed, there is little to give at Site 2.

Trying to be true to his Buddhist teachings, Samnang does not chase away the rats that come to steal his rice at night, because, he believes, they too are hungry and have to eat.

Midwife Ouk Sokunna listens to the fetal heartbeat through a cone-shaped stethoscope, then helps with the birth of Thep Soeung's baby in American Refugee Committee Hospital's delivery room. For the difficult birth, forceps are sterilized by placing them in a bowl of alcohol and then lighting it with a match.

Future generations are born at Site 2, as they are everywhere. With more than 9,000 new babies a year, the camp has a birth rate of 4.8 percent, one of the highest in the world. To guarantee safe and healthy deliveries, the Khmer have entrusted their future to a cadre of hard-working and highly disciplined midwives. Men are not permitted to participate in the birth process, and it is one of the few avenues for women to attain a measure of status at Site 2.

So far, only men have been doctors at the camp. Ouk Sokunna, age 23, is one of two women enrolled in the medic program. Sokunna has been a midwife at the American Refugee Committe Hospital for three years and has delivered hundreds of babies.

"Now I have the opportunity, and want to keep studying," she says. Only 50 percent of the births are at the hospital. The rest are delivered at home. However, Sokunna's mother will not let her do home deliveries, because she feels she is too young.

The father and mother hold their new baby, and the father beams with pride and joy. The camp birthrate is one of the highest in the world.

Thep Soeung lies on a bamboo birthing bed, moaning softly. A team of midwives massage her, serve her water, and wipe sweat from her forehead. The delivery room is a large cement-floored bamboo annex separated from other patients by bamboo doors. Colorful sarongs sewn together partition the three birthing beds, all occupied.

A square hole is cut from the bed's end for delivery. Here Sokunna is coaching 27-year-old Soeung, telling her to breathe deeply and push.

After two spontaneous abortions, this is Soeung's first live birth. Still wrapped in her sarong, she is quiet during labor, making few groans.

It is a difficult birth, and a senior midwife takes over while Sokunna watches. The baby emerges without a whimper. Almost immediately another expectant mother is rushed in by two men carrying a hammock.

Prom Thorn, age 38, is the chief Khmer midwife at the A.R.C. Hospital. Daily she confronts problems that face the specialists in hospitals worldwide.

The news can be bad, but usually the baby is healthy and the parents are happy. Being a midwife has made her very proud. "We will be doing this work back in our country some day," she says. "We feel like we are the future."

*Thep Soeung turns
to look at her
newborn baby boy,
another Khmer child
swelling the
population of Site 2.
Much of the
Cambodians' hope
for the future rests
with this burgeoning
generation.*

ACKNOWLEDGMENTS

In the four years of making this book a reality, it grew from a personal project to a group effort of many friends and acquaintances, both old and new, who gave generously of their time, insights and extraordinary talents. I want to express my deepest gratitude to all of them, and especially the following: Donald and Marilyn Scott, who hold a commitment to the people of southeast Asia, provided the encouragement and support that was the impetus for doing this book in the first place.

Josh Getlin's compassion and interest in refugee issues led to his introduction and text, giving the photos and stories of Site 2 residents a critical social and historical perspective. He stuck it out through all the difficult and dangerous times.

Chuck Nigash's friendship, perseverance and enormous talent have been instrumental in shaping this book's concept and design from the beginning.

Carol Treat Morton enthusiastically took on the eye-straining task of carefully editing more than 10,000 images, a process that took months of late-night sessions.

Marshall Lumsden came to the rescue as editor and advisor when it came time to pull all the pieces together.

Idamae Blois Brooks did a tremendous job of copy editing and offering advice and much more.

Andy Pendleton, of the United Nations Border Relief Operation, shared his insights gained from working closely with the Khmer on the Thai-Cambodian border. His friendship and assistance were invaluable.

In Site 2 itself, Chan Peov and his family welcomed me into their home and their lives. So did Oum Kheama, Chhom Samnang, Chhiek Ieng Thai, Nuon Phaly, Chea Sokha, Ros Wanna, Khiev Eng, Venerable Heng Monichenda. Along with many others, they shared their pain and their hope for a better, if uncertain, future.

Prum (Phon) Sakal, now starting a new life in France, was my patient interpreter and friend. Chan Bona spent countless days interpreting and finding access to the elusive mystical healers, soldiers, and murderers. Sontaya Gesornprom of D.P.P.U. was a helpful and usually unobtrusive "guide."

Father Pierre Ceyrac and the staff at Catholic Organization for Emergency Relief and Refugees were particularly helpful to Josh Getlin and me, as were Dr. Robert Brands, Liz Bernstein, Lori-Anne Pennels, Dr. Louie Braile, Dr. Jim Kublin, Poonsri Meeroslum, and many other relief workers and U.N.B.R.O. staff at Site 2 whose kindness and sharing of observations helped make this book possible.

The hospitality of my friends at the Inter Hotel helped me to survive far from home.

Vora Huy Kanthoul, Associate Executive Director of United Cambodian Community, gave invaluable help in proofreading and making suggestions on our reporting of Cambodian culture. Also helpful were Diana Bui of Indochina Resource Action Center, Dr. Haing Ngor, Sam Oum, Susan Goodwillie, Court Robinson of U.S. Committee for Refugees, Venerable Kong Chhean and Venerable Benton Pandito, Nadine Selden, and staff at Cambodian Family Services.

Wayne Kelly, professor of journalism at California State University, Long Beach, who guided me toward my career in photojournalism, provided many helpful suggestions during the production of this book.

Rick Perry's assistance with pre-press details was extremely helpful.

Heidi Evans, Brian Smith, Maria Newman, Don Tormey, Gary Ambrose, Henry DiRocco, Gianna Majzler, Steve Lopez, David Puckett, Dr. Jeanne Cross, Bryan McGowan, Diana Edkins Richardson, Cassy Cohen, Jerry Cohen, Scott Brown, Eric Healy, Liz Rodas, Robin Reisdorf, and many other friends and colleagues offered help, encouragement and companionship.

At Asia 2000, publisher Mike Morrow and senior editor Jan Krikke, made a genuine commitment to documentary photography with their guidance and confidence in this project.

My parents, JoAnne and Wayne, and brother Brian (Tim) gave me their love, understanding and support.

Finally, I would like to thank Chris Evans from the bottom of my heart for his endless patience, support and encouragement through all the difficult times.
– K.R.H.

POSTSCRIPT

Chan Peov, the amputee soldier whose story is told in "I Want to Survive and Make It On My Own," escaped from Site 2 camp, leaving his wife and children behind. Fearing for his life and bored with the mind-dulling routine of the camp, he walked out only with the clothes on his back.

Several days later Chan Peov appeared at Site B, a camp loyal to Prince Sihanouk. After a few months of sleeping on the ground without a ration book or hut, Peov managed to get enough money to arrange to have his family smuggled out to join him.

He soon returned to the battlefield as a platoon commander for the National Army for Kampuchean Independence, a non-Communist ally of the K.P.N.L.F. and the Khmer Rouge, fighting against the Phnom Penh government troops.

Tragedy nearly struck again when Chan Peov took his family to a guerrilla base inside Cambodia. An artillery shell narrowly missed his wife and younger daughter as they ran for shelter during an enemy attack. Nak has dropped out of school and her father has also given up any hope of education. Today, they are poorer than ever.

Chan Peov recently sent this picture, posing proudly with his new American-made weapons, an M-16 rifle and an M-79 rocket-propelled grenade launcher. He props his new Fiberglas leg against the barbed-wire barrier, heavily mined on both sides, which separates Cambodia and Thailand.

Lyrics of a song by Chan Peov are printed on the next page in English and original Khmer.

ខេត្តកោះកុង

និ.'ខេត្តកោះកុង អាយុខ្ចីម្លេះ នឹ សម្លាញ់រើយ
ស្ពាយមិនគួរបស់សង្ខារ ក្រេរៀយ អស់និ មិត្តរវៀយ អភ័ព្ធ
ងួបជុំគ្នាហើយរប្លូតឆ្លៀយមិនភាប់ ហាក់ឲ្យចំងណាត់ គ្នាស្លាប់
ឲ្យខ្ញុំ ធុកឈាប់វេក្ចាងនួការម្លេ៎រទ ។

ស្រវាញ៉េគ្នាណាស់ កម្មផ្ទៃព្រាត់ព្រាសនៅបាន
ស្ងប់ព្រលិង មិត្តទាំងពីរ្រ្ពលាសា ឲ្យមិត្តបាន សុខសាន្ត្ររៀងរហូតរវៀយ ។

មិត្តរវៀយខ្ញុំ ស្ពាយមិត្តណាស់ ថ្ងៃលងនាយសិ្វច្ឆាត់នៅ៎រហើយ
និ ថ្ងៃលវៀយទារ្រាសិ៎ងរូក ផ្លេចធុងួស្របរភាក់ គ្មាន ឈប់
ម្លេច សម្ទ្រមានរស់ ជាតិ៎រ្បៃ មនុស្សលោករកើតមកធ្វើ្វី
របី៎រកើតមកក្រៃបរទៅវិញ្ញាដ៏ស្ល ។

CHAN PEOV'S 'SOLDIER'S SONG'

Why was your life so short, dear friends,
 in the Province of Kohkong?

There was no reason for you to die,
 my unfortunate friends.

Were we brought together simply to be
 parted by an appointment with death?

 I am burning with grief.

We shared love one for the other,
 but karma has divided us.

 I pray that your souls have found peace.

My dear friends, the setting sun in the
 distance asks for your spirits.

 Why do I have this never-ending sorrow?

 Why is the sea so salty?

 Why are we born only to die?